IMAGES
of America

JOHNSON COUNTY

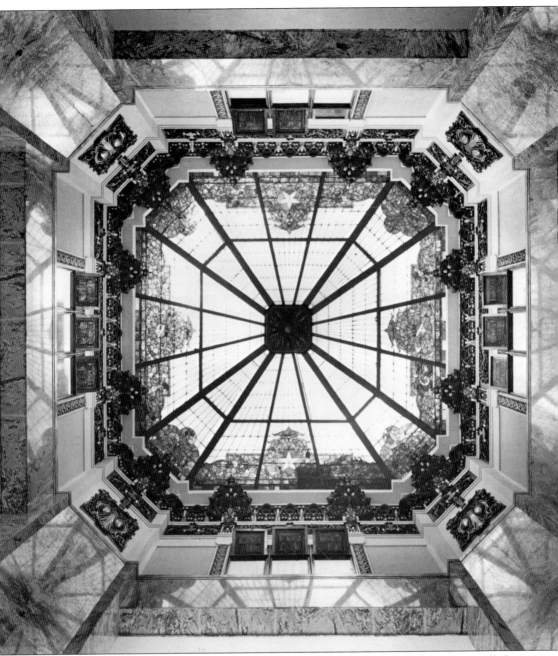

JOHNSON COUNTY COURTHOUSE ART GLASS DOME. The open rotunda, six stories tall, features a stunning octagonal art glass dome, made of a combination of stained glass and textured clear glass. Foster Stained Glass Studio repaired the sections in 2003, replacing some glass and repairing the leading. Earlier work had been done with glass from Kokomo Opalescent Glass and Paul Wissmach Glass Manufactures. Sam Gatewood took this photograph in 1976. (Courtesy of Layland Museum.)

ON THE COVER: Completed in 1913, the grand Texas Renaissance–style Johnson County Courthouse is listed in the National Register of Historic Places. (Courtesy of Layland Museum.)

IMAGES
of America

JOHNSON COUNTY

Mollie Gallop Bradbury Mims

ARCADIA
PUBLISHING

Published by Arcadia Publishing
Charleston, South Carolina

Printed in the United States of America

Library of Congress Control Number: 2013946955

For all general information, please contact Arcadia Publishing:
Telephone 843-853-2070
Fax 843-853-0044
E-mail sales@arcadiapublishing.com
For customer service and orders:
Toll-Free 1-888-313-2665

Visit us on the Internet at www.arcadiapublishing.com

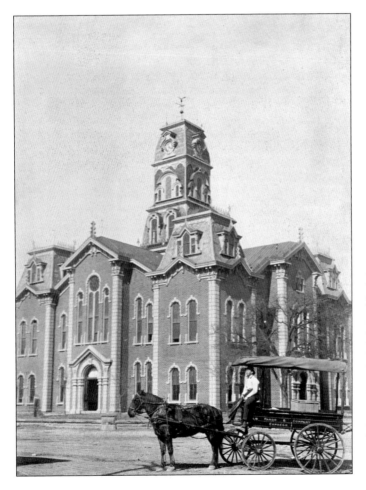

DELIVERING CARGO AND CASH. Designed by Wesley Clark Dodson, this 1883 courthouse had a bell tower and ornate decorations. It was surrounded by dirt streets. The structure burned down on April 15, 1912. The Wells Fargo & Company wagon shown here was driven by Burton Shannon. (Courtesy of Layland Museum.)

CONTENTS

ACKNOWLEDGMENTS

The longer I search for quality original photographs about our local history, the harder it is to find a new one. However, from personal scrapbooks and files, new donations to the Layland Museum, and former residents located by way of the Internet, there are many fresh views of old sites. As a bonus, this book includes a few images never before published.

Those images are now a part of our recorded and preserved history. Even the images not printed in this book will be protected at the Layland Museum for the benefit of the next historical researcher.

A birth certificate proves we were born. A death certificate proves we died. Photographs prove we lived.

Our lives—on the job, with families, in church, and during free time—is what this book is about. It is a daunting task to give the reader a snapshot of our history in a finite number of pages, covering the formation of the county to the year 2013.

Most of the photographs are courtesy of the files of the City of Cleburne's Layland Museum. Thanks are due to its staff for continued assistance and encouragement. Also, thanks go to the Johnson County Historical Commission Museum staff and volunteers, the Burleson Historical Foundation, and the Joshua Chamber of Commerce. Individuals shared photographs or negatives from their personal collections for scanning. Thanks to each person who has helped tell the story of our county.

My husband, Larry G. Mims, and I have traveled the back roads, shooting photographs, interviewing residents, and searching for information. Thank you "PaPa" for sharing this time and making memories.

To the readers: enjoy this reflection into our past and work to preserve it for our future.

INTRODUCTION

Johnson County's history and people are as diverse as its four geographic regions: the cedar brakes, the grand prairie, the cross-timbers, and the blackland prairie. From the backbreaking labor of early agriculture and ranching to cutting-edge manufacturing, mechanized farming, and skilled professional services, the residents continue to change with the times.

In the early years, there were cattle trails and wagon trails. In 2013, residents are preparing for the completion of the Chisholm Trail Parkway, which will more efficiently connect the western part of the county to the Metroplex and the Dallas–Fort Worth Airport.

This introduction reflects on a time before cameras. Only a few accounts were penned about the formation of what is now called Johnson County.

Before the area was a county, Pedro Vial, an excellent pathfinder, interpreter, and agent to the Indian country, likely crossed it while traveling from Santa Fe to Natchitoches, Louisiana. Philip Nolan, a horse trader and freebooter, was attacked and killed on Noland's River, later called Nolan River in his honor. These explorers may have discovered these lands, but they did not stay.

Although no permanent Indian villages were recorded, tribes traveled and camped across the land that became Johnson County. The Kickapoo, Tonkawa, Anadarko, Caddo, and Waco would hunt turkey, deer, and buffalo. There were also mustang ponies, wolves, and antelope.

When brave Texans were fighting for their independence, the territory we now call Johnson County was in the Mexican municipality of Milam. The land comprised approximately one sixth of the land in Texas.

After Texas gained its independence in 1837, this municipality was changed to a county of the same name. In 1850, McLennan County, which included the territory of Johnson County, was cut off from Milam. In February 1854, Johnson County was cut off from McLennan County by an act of the legislature.

The original area of Johnson County was 1,376 square miles, but in 1866, it lost 636 square miles (nearly half the territory) when Hood County was cut off the western side of the county, leaving the present area of 740 square miles.

After Texas's admission as a state in 1845, the county's natural resources and open lands drew many immigrants. The first settlers included Henry Briden, who made his home in a log cabin on the Nolan River in 1849. Samuel Myers and Maj. E.M. Heath settled in Alvarado, the first town in the county, and the D. Smith and W. Meadows families settled on Chambers Creek in the eastern part of the county. By 1852, there were 24 families keeping residence in the county. By the winter of 1853–1854, more than 100 families called the area home.

A petition was signed by 107 residents to ask for the formation of Johnson County in 1854. E.M. Heath was appointed secretary and drew up the petition and was made commissioner to help organize the county. The state granted the county formation on February 13, 1854.

Families continued arriving, and communities were organized during the next generation. Only a handful of those settlements and few images survive, but their histories are a rich part of our past.

The Grand State Farmers' Alliance of Texas was one of the many farmers' alliances formed during the late 19th century. The purpose of these alliances was to provide isolated rural farmers with a community and the ability to collectively advocate for legislation supporting agriculture. The Texas Farmers' Alliance adopted what became known as the "Cleburne Demands" at a convention held in August 1886 in Cleburne, Texas.

One of the goals of the organization was to end the adverse effects of the crop-lien system on farmers in the period following the American Civil War. The alliance also generally supported the government regulation of the transportation industry, establishment of an income tax to restrict speculative profits (particularly the railroad industry), and the adoption of an inflationary relaxation of the nation's money supply as a means of easing the burden of repayment of loans by debtors. The alliance moved into politics in the early 1890s under the People's Party, commonly known as the Populists.

In the decades following, businesses sprang up mostly around the center of towns and included dry goods merchants, drugstores, saloons, banks, churches, and schools. Now, retail areas and industrial parks provide jobs for many of the more than 150,000 residents.

As we have continued to grow and change, Johnson County has been sprinkled with rooftops, drilled wells, and earthquakes. Those with a love of local history have tried to preserve a few precious peeks into the past so that new immigrants and future generations will have a better understanding of the county's beginnings and growth.

This book links us with the past through well-researched descriptions and treasured images.

One

ESTABLISHING A COUNTY

MIDDLETON TATE JOHNSON.
After serving in the Mexican
War and receiving a land grant
in Tarrant County, Middleton
Tate Johnson established a
cotton plantation and donated
land for the Tarrant County
courthouse. The namesake for
Johnson County, he was a Texas
Ranger and a Civil War veteran.
About 150 families lived in
the county in 1854. (Courtesy
of Tarrant County College
Northeast, Heritage Room.)

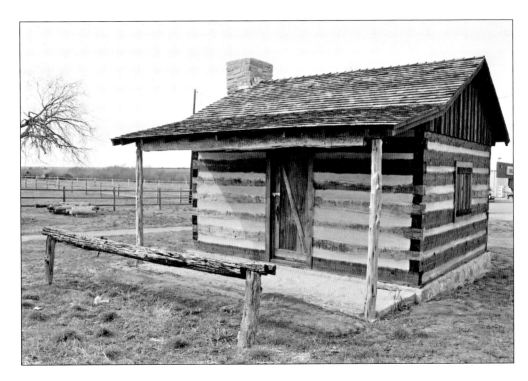

PIONEER BRIDEN FAMILY. Henry Briden came to the United States as a stowaway with only his clothes and a Bible. He served in the Texas Rangers for two years before meeting Lucinda Sevier while working as a surveyor for her father. They married in 1849 and arrived in this area by ox-driven wagon, making their home in a one-room log cabin (above) near the banks of Noland's River on land given to them by her uncle. They were the first settlers in what is now Johnson County. This cabin, 16 feet square with a fireplace, has been restored and is now located on Highway 174 in Rio Vista. Below is the Bridens' third home, located about two miles northwest of Rio Vista, in 1900. The couples shown here are, from left to right, Henry and Lucinda Briden, Mr. and Mrs. Henry Taack, and Mr. and Mrs. Tom Sloan with Lola Sloan. (Both, courtesy of Mollie Mims.)

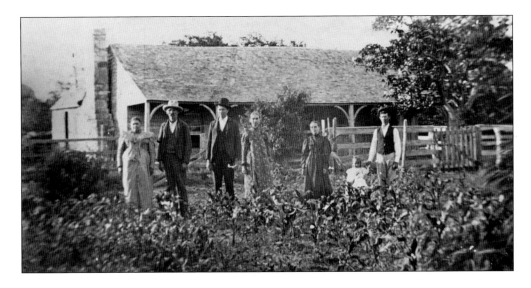

PIONEER MYERS FAMILY. Samuel Myers and his wife, Martha "Patsy" Myers, came to Texas with their children in 1851. Besides owning 3,000 acres of farmland near what is now Alvarado, Myers was the county's first financier, loaned money, sold foodstuffs on credit, and built the first school on his land. One of his cabins is now at Johnson County Pioneers and Old Settlers Reunion. (Courtesy of Mollie Mims.)

FIRST SHERIFF ELECTED. Abraham Onstott, born in Missouri in 1825, crossed Texas by ox-driven wagon to join the Texas Volunteer Cavalry in 1846. After mustering out, he peddled horses across the state, meeting and marrying Amelia Farber. The Onstotts' land grant was in eastern Johnson County. He named the town Alvarado after a town in Mexico. Onstott was elected the first sheriff in 1854. (Courtesy of Mollie Mims.)

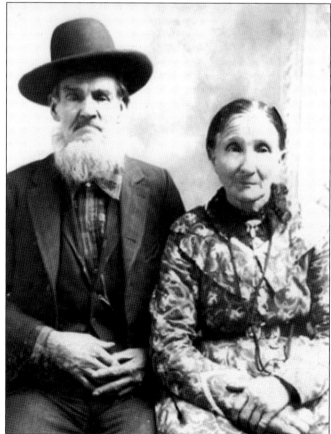

WARDVILLE COURTHOUSE RESTORED. The first courthouse (above), a 14-foot-square log cabin with one window and a dirt floor, was constructed in Wardville, the first county seat. After the county seat was changed to Buchanan, the structure was moved, and it eventually became part of the Eldon and Opal Kouns family home on County Road 426 in the Midway community. C.R. and Billie Shaw owned the property in 1991 and donated the old courthouse to the Chisholm Trail Outdoor Museum, near the site of Wardville, west of Lake Pat Cleburne. Pictured below are Billy Cate (left) and Johnson County sheriff Bob Alford with the restored courthouse in the background. Cate and Jack Carlton were instrumental in organizing the site. The Chisholm Trail led cowboys and cattle to Kansas. (Both, courtesy of Billy Cate.)

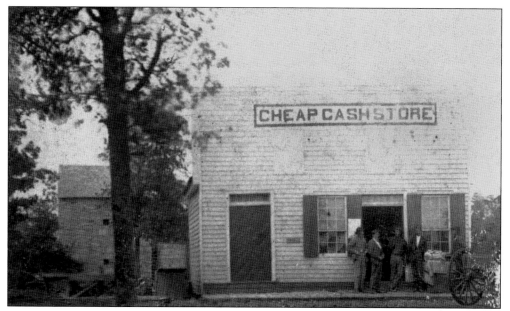

BUCHANAN COURTHOUSE MOVED. A one-room wooden courthouse was built in the second county seat, Buchanan, five miles northwest of Cleburne. Camp Henderson, established during the Civil War, was chosen for the third county seat because of its location and ample water supply. The Buchanan courthouse, later operated as the Cheap Cash Store, and the jail (pictured behind the store) were moved to the southeast corner of the public square in 1867. (Courtesy of Layland Museum.)

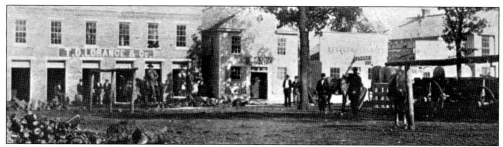

EARLY CLEBURNE SQUARE. Pictured here in 1872 are some of the businesses on the north side of the Cleburne square, including T.D. Lorance general merchandise and the Chambers & Brown Bank. Before 1870, Cleburne's population was about 200. There were several log homes, boardinghouses, saloons, a 10-pin alley, and a general store. Fresh water for the town came from Joe Shaw's springs on Buffalo Creek. (Courtesy of Layland Museum.)

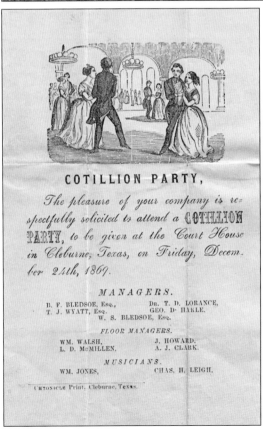

COTILLION PARTY,

The pleasure of your company is respectfully solicited to attend a COTILLION PARTY, *to be given at the Court House in Cleburne, Texas, on Friday, December 24th, 1869.*

MANAGERS.

B. F. BLEDSOE, Esq., Dr. T. D. LORANCE,
T. J. WYATT, Esq. GEO. D. HARLE.
W. S. BLEDSOE, Esq.

FLOOR MANAGERS.

WM. WALSH, J. HOWARD,
L. D. McMILLEN, A. J. CLARK.

MUSICIANS.

WM. JONES, CHAS. H. LEIGH.

Chronicle Print, Cleburne, Texas.

BRICK COURTHOUSE AND PARTY. The town was renamed Cleburne, honoring Irish-born Confederate general Patrick Cleburne. He had been a respected leader of many local soldiers. Prior to serving in the Civil War, Cleburne had been an attorney and a druggist. The third courthouse (above), and the first constructed in Cleburne, was completed in 1869. It was a square, two-story brick structure with an open, T-shaped hallway. Costing over $10,000, it stood in the center of the square, surrounded by a wood fence. After its completion in April, a formal party was held on December 24. Hotel owner Josephine Wren provided a lavish reception and entertainment just across the street in the grand lobby of the Cleburne House. Cleburne was incorporated in 1871. (Both, courtesy of Layland Museum.)

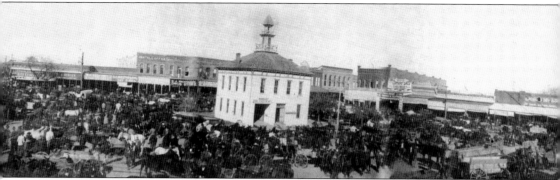

THE FIRST TOWN SETTLED. William Balch arrived in 1849 to stake a claim on his land grant on an Indian trail, and he returned in 1851 to settle the town of Alvarado. A Caddo Indian family was living nearby. The area was home to wild turkeys, quails, black bears, buffalo, mustangs, wolves, and deer. He donated land for a school, Balch Cemetery (located on South Cummings Drive), and Union Church. By 1854, Alvarado had about 100 families and postal service. A city hall, including the jail, was erected in the center of the square in the 1880s. The fire department, organized in 1885, operated on the first floor. Establishments around the square included doctors, attorneys, a Well Fargo office, a hotel, an opera house, and general merchandise stores. During the same decade, railroads arrived in Alvarado, and the population grew from 350 in 1880 to 1,500 in 1882. It was incorporated in 1878 but had been a thriving community for many years. The photograph was taken around 1885. (Courtesy of Michael Percifield.)

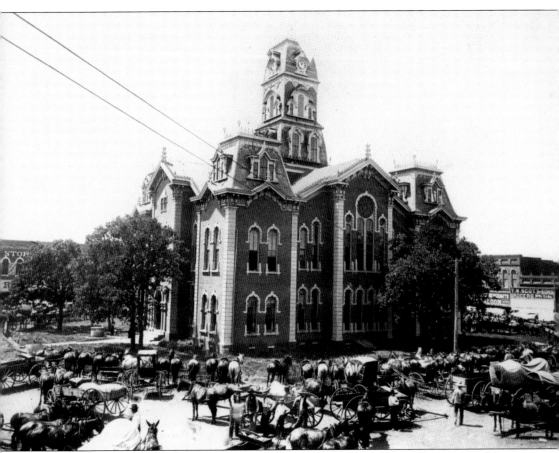

THE CENTER OF BUSINESS. Families gathered around the courthouse in the center of Cleburne for parades, shopping, and to sell farm, poultry, and dairy products. About 50 loaded wagons arrived daily. Completed in 1883 at a cost of $44,685, this brick and stone courthouse had a bell tower with a clock and ornate decorations. By this time, there were a variety of professional offices and businesses in Cleburne, including 8 laundresses, 3 cotton buyers, 2 ministers, 27 farmers, 22 public officials, 19 lawyers, 12 bartenders, 6 carriage makers, 16 laborers, 5 restaurants owners, 12 teachers, and 1 undertaker. Limited telephone service began in 1882. Campbell Dickson took over the hardware store in 1878, selling tinware, appliances, and furniture. The Chambers Hotel was on the second floor of the hardware store. Market Square opened in 1898 to accommodate the growing number of individuals selling products and to ease congestion for thriving business around the courthouse. On July 4, 1907, a ball was held in the courthouse; the same year, Mr. and Mrs. L Freeman were married on the top of the tower. Stores surrounded the square. (Courtesy of Layland Museum.)

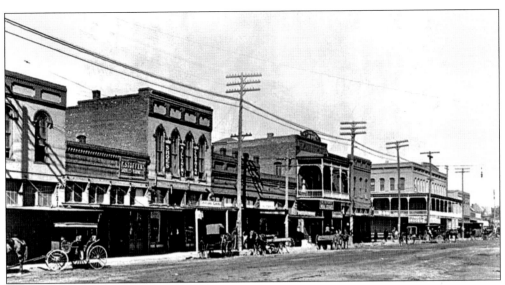

AROUND THE SQUARE. Before the three-story Cleburne Hotel (also referred to as the Cleburne House, pictured above at far right with a wraparound porch), Josephine Wren built a log cabin and opened a tavern and boardinghouse at that location, northwest of the square. The Cleburne House had 50 rooms, costing $2 per day. The lower floor housed businesses and the hotel lobby. By 1860, the county's population was 4,305, Indian corn was the main crop, and livestock was the primary industry. Pictured below is Chambers Street, on the south side of the square, looking east around 1900. The three-story building in the distance is the Brown Opera House, built in 1877, at the corner of East Chambers and South Anglin Streets. Downstairs, John C. Brown sold carriages and buggies, while upstairs, he hosted live entertainment until the facility closed in 1911. In 1891, the Hirt & Miller Meat Market opened on North Anglin Street. It later added a slaughterhouse. (Both, courtesy of Layland Museum.)

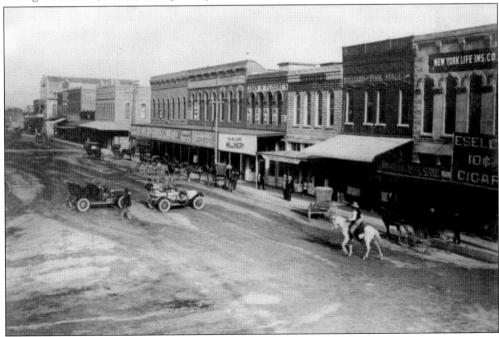

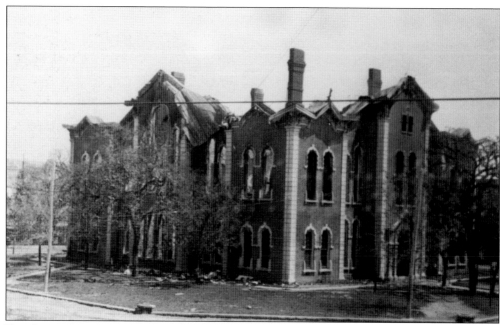

FIRE CLAIMS LIFE. On April 15, 1912, the same day the RMS *Titanic* sank, a nighttime fire destroyed the courthouse. Most of the valuable records were saved, but city marshal Albert Bledsoe died in the fire. Attorney Meek L. Daniels (below) had moved his office into the courthouse not long before the fire occurred. He failed to change his insurance to the new location, however, and lost the entirety of his $600 investment, which, by today's standards, would be about $14,000. Daniels served as justice of the peace before passing away in 1923. (Above, courtesy of Layland Museum; below, courtesy of D. Wiley Whitten Jr.)

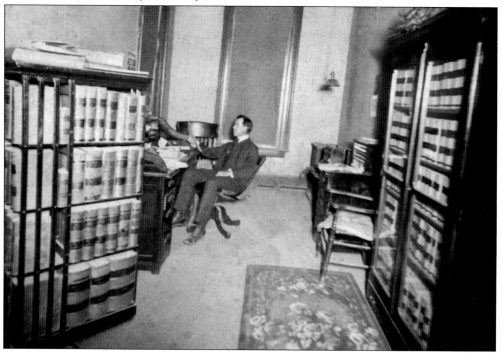

MONUMENTS AND MARKERS. City officials allowed residents to remove bricks and debris from the rubble of the 1883 structure. Dub Collins took the stone date marker (right). It was returned to the county in 1990 and is located near the east courthouse entrance. A Confederate monument with two benches was added to the lawn on the southeast corner in 1917. In 1964, a Gen. Pat Cleburne granite memorial was placed on the northeast corner. The bicentennial marker was added on the southwest corner in 1976. On the northwest corner stand two markers: a World War II and a Pearl Harbor memorial. The Texas Historical Commission marker below was placed in 1970 and the Texas Sesquicentennial marker in 1986. (Both, courtesy of Mollie Mims.)

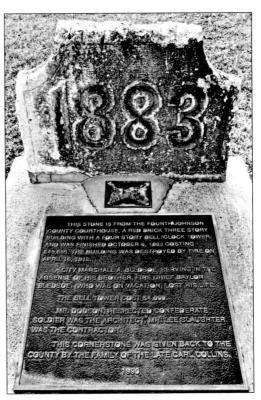

THIS STONE IS FROM THE FOURTH JOHNSON COUNTY COURTHOUSE, A RED BRICK THREE STORY BUILDING WITH A FOUR STORY BELL/CLOCK TOWER, AND WAS FINISHED OCTOBER 6, 1883 COSTING $49,685. THE BUILDING WAS DESTROYED BY FIRE ON APRIL 16, 1912.

CITY MARSHALL A. BLEDSOE, SERVING IN THE ABSENCE OF HIS BROTHER, FIRE CHIEF BAYLOR BLEDSOE, (WHO WAS ON VACATION) LOST HIS LIFE.

THE BELL TOWER COST $4,000.

MR. DODSON, RESPECTED CONFEDERATE SOLDIER WAS THE ARCHITECT, MR. LEE SLAUGHTER WAS THE CONTRACTOR.

THIS CORNERSTONE WAS GIVEN BACK TO THE COUNTY BY THE FAMILY OF THE LATE CARL COLLINS.

1990

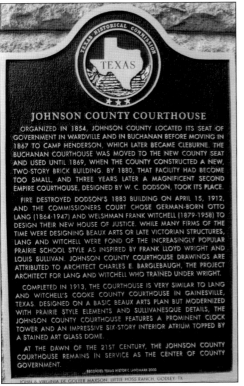

JOHNSON COUNTY COURTHOUSE

ORGANIZED IN 1854, JOHNSON COUNTY LOCATED ITS SEAT OF GOVERNMENT IN WARDVILLE AND IN BUCHANAN BEFORE MOVING IN 1867 TO CAMP HENDERSON, WHICH LATER BECAME CLEBURNE. THE BUCHANAN COURTHOUSE WAS MOVED TO THE NEW COUNTY SEAT AND USED UNTIL 1869, WHEN THE COUNTY CONSTRUCTED A NEW, TWO-STORY BRICK BUILDING. BY 1880, THAT FACILITY HAD BECOME TOO SMALL, AND THREE YEARS LATER A MAGNIFICENT SECOND EMPIRE COURTHOUSE, DESIGNED BY W. C. DODSON, TOOK ITS PLACE.

FIRE DESTROYED DODSON'S 1883 BUILDING ON APRIL 15, 1912, AND THE COMMISSIONERS COURT CHOSE GERMAN-BORN OTTO LANG (1864-1947) AND WELSHMAN FRANK WITCHELL (1879-1958) TO DESIGN THEIR NEW HOUSE OF JUSTICE. WHILE MANY FIRMS OF THE TIME WERE DESIGNING BEAUX ARTS OR LATE VICTORIAN STRUCTURES, LANG AND WITCHELL WERE FOND OF THE INCREASINGLY POPULAR PRAIRIE SCHOOL STYLE AS INSPIRED BY FRANK LLOYD WRIGHT AND LOUIS SULLIVAN. JOHNSON COUNTY COURTHOUSE DRAWINGS ARE ATTRIBUTED TO ARCHITECT CHARLES E. BARGLEBAUGH, THE PROJECT ARCHITECT FOR LANG AND WITCHELL WHO TRAINED UNDER WRIGHT.

COMPLETED IN 1913, THE COURTHOUSE IS VERY SIMILAR TO LANG AND WITCHELL'S COOKE COUNTY COURTHOUSE IN GAINESVILLE, TEXAS. DESIGNED ON A BASIC BEAUX ARTS PLAN BUT MODERNIZED WITH PRAIRIE STYLE ELEMENTS AND SULLIVANESQUE DETAILS, THE JOHNSON COUNTY COURTHOUSE FEATURES A PROMINENT CLOCK TOWER AND AN IMPRESSIVE SIX-STORY INTERIOR ATRIUM TOPPED BY A STAINED ART GLASS DOME.

AT THE DAWN OF THE 21ST CENTURY, THE JOHNSON COUNTY COURTHOUSE REMAINS IN SERVICE AS THE CENTER OF COUNTY GOVERNMENT.

RECORDED TEXAS HISTORIC LANDMARK 2000

JOHN & VIRGINIA DE GOLYER MAXSON, LITTLE HOSS RANCH, GODLEY, TX

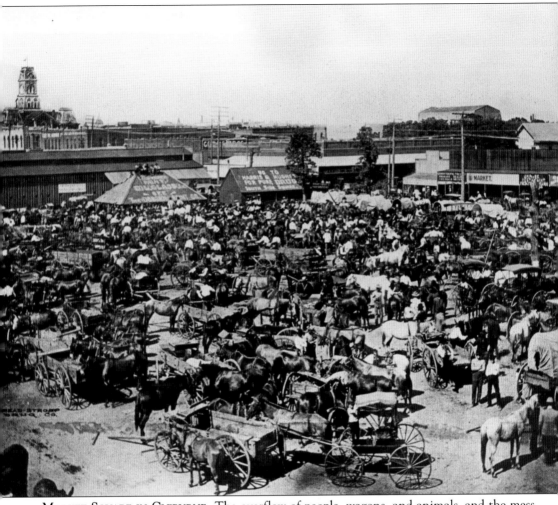

MARKET SQUARE IN CLEBURNE. The overflow of people, wagons, and animals, and the mess it left in its wake, made it difficult to conduct regular courthouse business around the square. On Monday, March 21, 1898, the Johnson County Commissioners met at the courthouse to officially purchase Block 24. Located on the west side of South Main Street, it was established for the express use as a free marketplace for the community and surrounding areas. Joe Mickle, the owner of most of the block that was to be Market Square, was paid $1,650 by the county for his property. P.C. Chambers owned the remaining lot and allowed the county to have his land for $5. In 2011, the county commissioners, in cooperation with the City of Cleburne, began a renovation of Market Square, including the addition of public bathrooms, lighting, rockwork, and sidewalks. In March 2013, the City of Cleburne was assigned the job of maintaining and operating the historic site. The Save Old Cleburne organization sold bricks that will be placed at the location. (Courtesy of Layland Museum.)

Two

GROWING A COUNTY

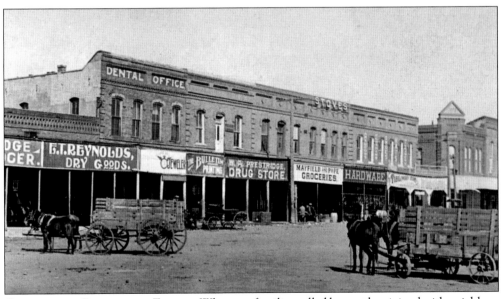

COMMUNITIES CONTINUE TO EMERGE. Wherever families called home, they joined with neighbors and grew a town, building a one-room school and a church, which was usually shared by all faiths. Most of these communities are lost except in memory or through an existing cemetery. Coyote Flats, the newest town in the county, was incorporated in 2010. Alvarado is seen here when the roads were dirt and the sidewalks mostly wooden. (Courtesy of Michael Percifield.)

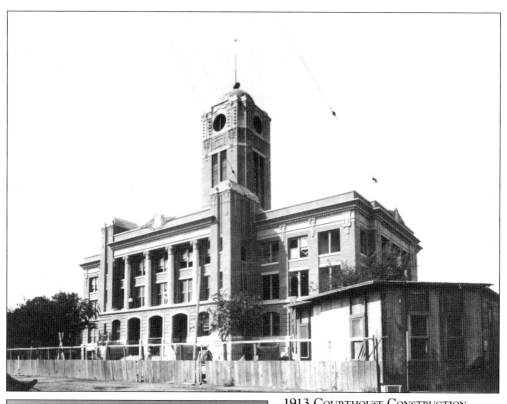

1913 Courthouse Construction. The architects for this structure were Otto Lang and Frank Winchell. Local resident E.J. Zimmerman gave his time to oversee the construction of this Beaux-Arts Classical three-story building. The exterior brick came from Elgin, Texas; the red granite came from Burnet County; the matched panels of polished marble were from Georgia; and the white stone was from Indiana. County officials moved into their offices in November 1913. (Courtesy of Layland Museum.)

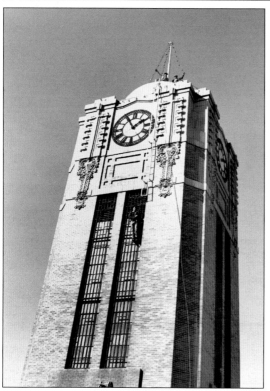

Cornerstone and Architecture. The cornerstone is located on the northeast corner of the structure. The basement is composed of smoothed Texas pink granite, and the first-floor brick is rusticated. In 1913, the county judge was J.B. Haynes and the commissioners were W.M. Hickman, R.E. Dillard, J.W. Shropshire, and G.W. Humphreys. In this 1950s photograph, workers string Christmas lights on the dome. (Courtesy of Layland Museum.)

GIANT COLUMNS AND PENDANTS. Incised on the upper section entablature over the columns is the inscription "A.D. Johnson County 1912." Symmetrically placed Sullivanesque pendants are at the sides and on the tops of the paired pylons on the east and west facades. Inside of the courthouse, all four sides have central colonnades with stylized giant composite-order columns. The building's cast-metal stairs have Prairie School balustrades, and the halls feature marble wainscoting and tile floors. The second and third floors are faced with smooth Elgin brick. Two-panel doors with brass hardware and crinkled-glass transoms lead to many offices. The right photograph, taken during restoration, shows the installation of the clock. Visible in the below photograph are interurban tracks, dirt roads, and low-hanging electric streetlights. (Right, courtesy of *Cleburne Times Review*; below, courtesy of Layland Museum.)

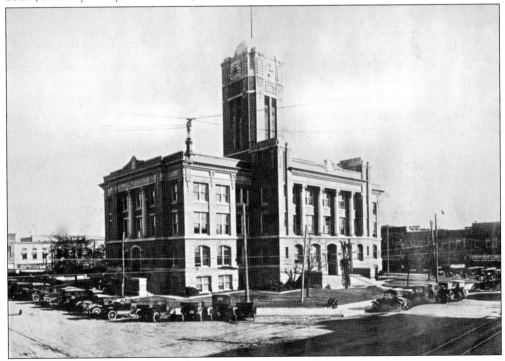

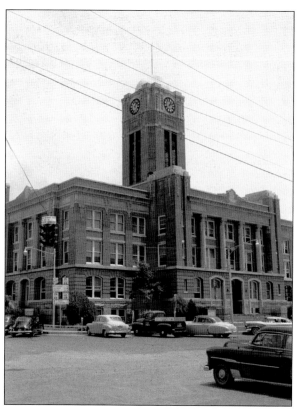

CENTER OF JUSTICE. Bustling with cars, two-way streets, and busy stores, Cleburne continued to be the center of government and business. By 1920, the population increased to 12,820 people. The courthouse closed in 2005 for exterior and interior work, including the restoration of the original paint scheme on the walls and reestablishment of the original height of the district courtroom. County offices had been moved to the 1919 Cleburne High School on South Buffalo Street after that building's complete renovation. It opened in 2004 as the Guinn Justice Center (below) and now houses the district courts and county courts at law. The exterior restoration of the 1913 courthouse was completed in 2007, and the building was rededicated on December 1. The interior restoration was completed by March 2008. (Left, courtesy of Layland Museum; below, courtesy of Mollie Mims.)

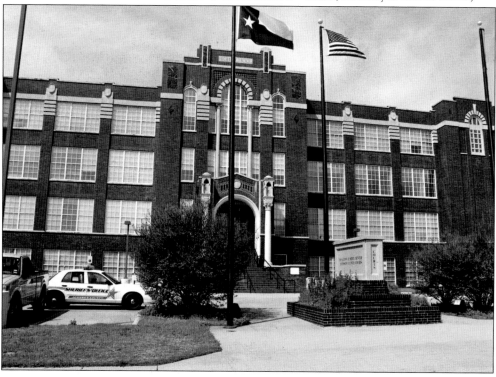

BELL AND CLOCK. Cast specifically for the new courthouse by Meneely and Company of New York, the bell is inscribed with the words "I ring for truth and justice." Over 50 years ago, the bell was placed on the west courthouse lawn, but it was returned to the roof after the restoration in 2007. The bell, synchronized with the clock, strikes on the hour. E. Howard Company of Boston made the original clockworks, composed mostly of brass. During restoration, Dr. E.L. "Elmo" Clark crafted new clock hands out of 300-year-old weather-resistant pressed Louisiana sinker cypress wood. The Johnson County Historical Museum, located in the courthouse, has a video of the working clock, showing the movements of its many parts. The image below shows a worker cleaning the clock face before replacing the hands. (Right, courtesy of Mollie Mims; below, courtesy of *Cleburne Times Review*.)

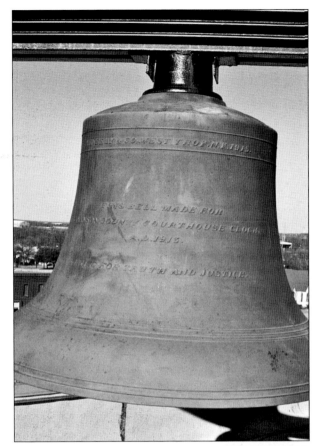

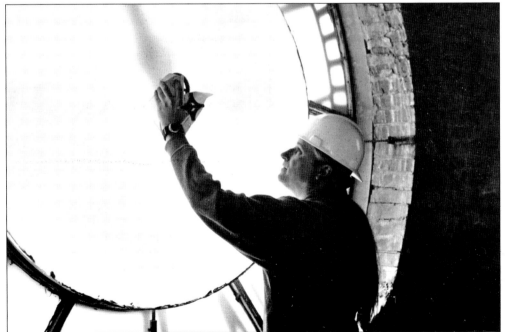

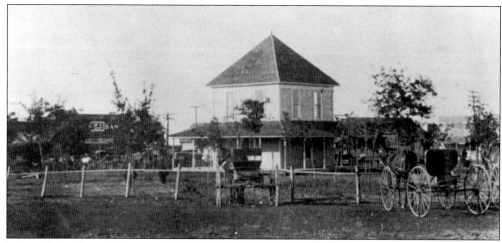

VENUS CITY HALL. This two-story frame structure in the center of Venus served as city hall and a two-cell jail. A domino hall was located upstairs. The first city council meeting was held here in July 1903, after the citizens voted to incorporate. Jim Wilson's buggy is seen in the middle of this photograph. (Courtesy of Layland Museum.)

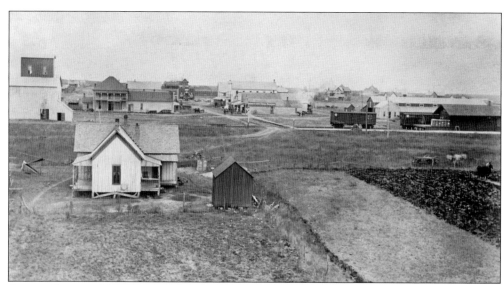

GODLEY GROWS A TOWN. In 1888, Godley had a post office, gristmill, three cotton gins, two dairy processing plants, and a station for the Gulf, Colorado & Santa Fe Railway. Until 1895, there were no schools or churches in town. A large school, known as Godley College, was erected, and within three years, the Methodists, Baptists, and Presbyterians all had buildings and congregations. (Courtesy of Layland Museum.)

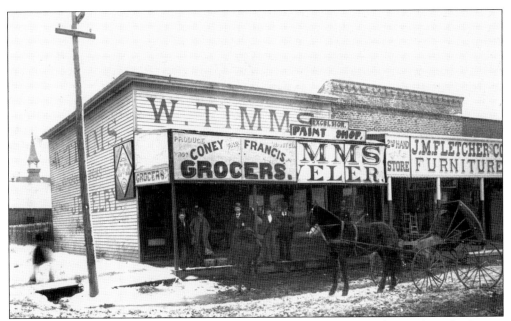

BUSY CORNER BUSINESSES. Before 1900 on the northeast corner of Chambers and Anglin Streets was Timms and Company jewelry store, owned by W. Timms and partners Witt Wilson and J.H. Styron. The location was also home to a grocery store owned by Coney and W.D. Francis and a furniture store owned by J.J. Fletcher. (Courtesy of Layland Museum.)

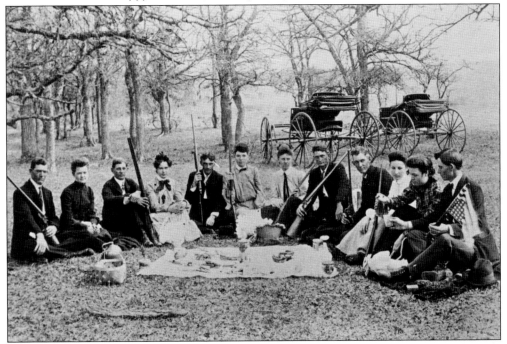

PICNIC ON THE GROUNDS. Hunting and sharing a picnic was a common activity during the early years of the county. This well-dressed group has gathered south of Burleson. From left to right are Marian Wilshire, Stella Wilshire, Mr. and Mrs. West, Pete Murphy, Janie Murphy, four unidentified, and Mr. and Mrs. Robert L. Anderson. (Courtesy of Layland Museum.)

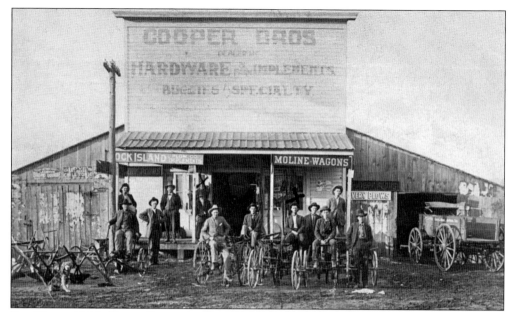

RIO VISTA, 1906. Henry Cooper had six sons, four of whom had a business in Rio Vista. The hardware store shown here was located at the west end of town. Members of the Cooper family also owned a grocery store and a buggy shop. Some of these businesses were destroyed by fire in 1914. (Courtesy of Layland Museum.)

JOSHUA BLACKSMITH SHOP. Located on Main Street near the old barbershop was the Joshua Blacksmith. Mr. Locker and Mr. Vincent, local blacksmiths, worked the dirty and hot job of forming metal into usable tools and other objects. L.H. Hunter, who sold buggies, hardware, wagons, saddles, and queensware, owned another popular early business. (Courtesy of Joshua Chamber of Commerce.)

EARLY ALVARADO BANK. Known by several names, the Alvarado Banking Company operated from the Cotter Dry Good store on the south side of the square. The bank's president was J.B. Campbell. In 1925, the bank was reorganized and became the Citizens State Bank, with Brooks Thompson as president. (Courtesy of the Martin family.)

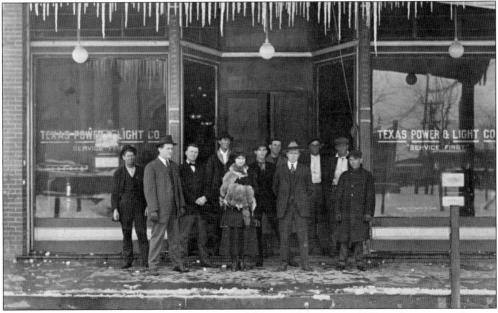

POWER OFF AND ON. Electricity was first available in Cleburne in 1888 with an incandescent system. The building burned in 1892, and no power was available until about 1885, when Cleburne Electric Light was established. The Texas Power & Light Company, located on North Caddo Street, where Cleburne Patrick's Floral is today, opened in 1912. The first electric appliance in town was an iron. (Courtesy of Layland Museum.)

KEENE, 1947. The Jeremiah Easterwood family arrived in 1852 and built a Methodist church, which also served as a school. The community, known as Elm Grove, was renamed Keene. A general store was established in 1893, soon after the Gulf, Colorado & Santa Fe Railway arrived. In 1894, the General Conference of Seventh-Day Adventists opened a school to train ministers. (Courtesy of Southwestern Adventist University.)

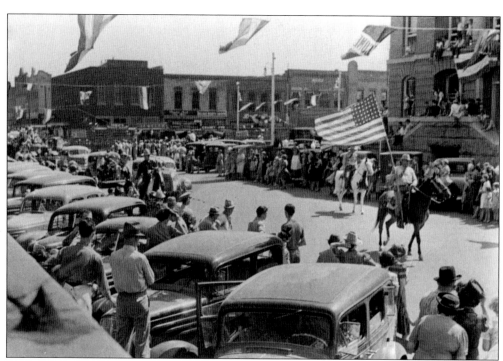

PARADE AROUND THE SQUARE. Leading a 1930s parade, businessman Charles D. "Charlie" Dickerson, on horseback, carries the American flag. Spectators lining Henderson Street and covering the steps of the courthouse look east at the approaching parade participants. Businesses on the east side of the courthouse included Clower Jewelry, Alta Souther Milliner, Palace of Sweets, Alexander's Café, and Chambless Shoes. (Courtesy of Dick Dickerson.)

Three

MAKING A LIVING

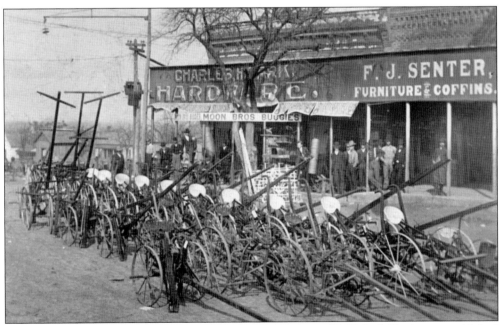

PARK HARDWARE. Alvarado was the first town in the county, and C.H. Park Hardware, established in October 1890, was the county's first hardware store. Grandson Roy Park was the last manager of the business, which closed in 1981. David Mitchell lived in a cabin a few miles east, selling trinkets and calico cloth to the Indians before the town was formed. (Courtesy of Michael Percifield.)

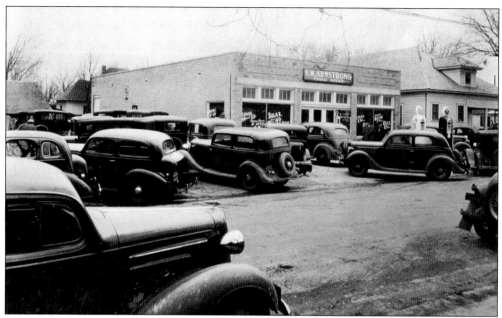

ARMSTRONG STORE IN CLEBURNE. Pictured on opening day in January 1937 at 411 West Henderson Street, this grocery store advertised itself as "A modern place with plenty of parking space" and free delivery. Owned by King William Armstrong, the store, like most early businesses, moved to have room for additional products. (Courtesy of Bill Pyeatt.)

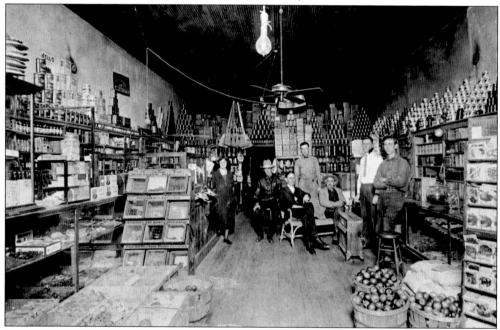

BLASSINGAME GROCERY STORE. Shelves and baskets of fresh fruit, garden seeds, baked goods, and basic staples are on display at Blassingame Grocer. Bakery products were from the Thousand Window Bakery, which became Sunshine in 1946. Several store locations, including 302 West Shaffer Street and 204 South Main Street, were run by Blassingame family members, including Fred, J. Wesley, Emma, Ruby, Carl, and Alvin. (Courtesy of M.R. Head family.)

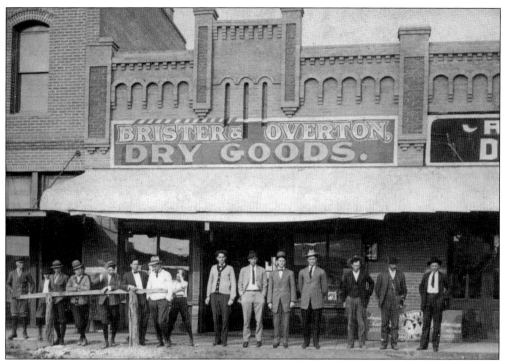

BRISTER & OVERTON DRY GOODS. Located in what is now referred to as "Old Town" in Burleson, this dry goods store stood at 104 South Main Street. Pictured here in 1914 are, from left to right, W.L. Russell, W.H. Haynes, Jim Scott, Guy Brister, Claude Overton, Glenn Martin, Bob Griffith, unidentified, Charley Hackney, J.W. Norwood, Chet Caffey, and four unidentified. (Courtesy of Burleson Historical Foundation.)

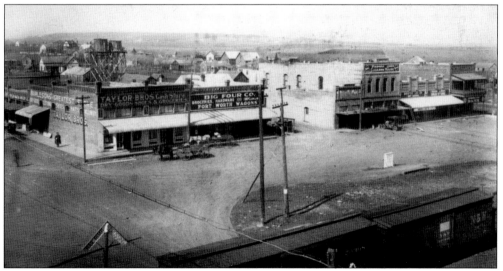

BURLESON STREET SCENE. Closed in 2005 after operating since 1903, the Big Four (center) was named for partners Charles Taylor, Robert Norwood, Sam Armstrong, and R.B. Armstrong. The store sold groceries, hardware, wagons, and furniture. After remodeling, Fresco's Cocina Mexicana opened in the location in 2007, adding more life into Burleson's revitalized Old Town. (Courtesy of Burleson Historical Foundation.)

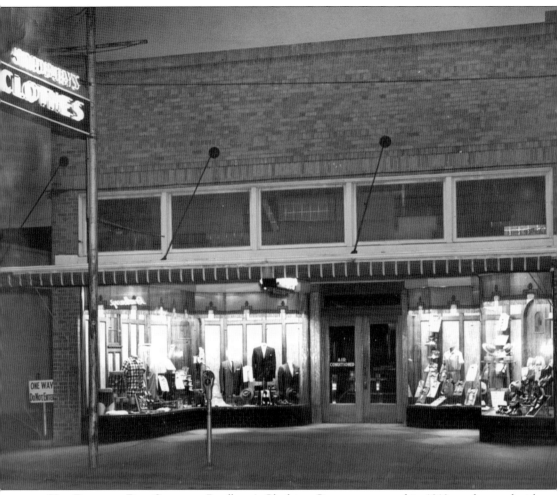

THE PLACE TO BUY CLOTHES. Bradbury's Clothing Company opened in 1910 on the south side of the square. It is pictured here at its last location, 106 South Main Street in Cleburne. It was the largest men's store in the county for generations until it closed in 1983. Owner W.T. Bradbury bought and sold in cash only and personally picked the fabric for the suits sold in the store. (Courtesy of Layland Museum.)

CHICK DAY. Anticipated every spring was "Chick Day" at Johnson County Feeder Supply, when adults and children flocked to buy baby chicks dyed in a variety of colors. Opened in 1950 by E.M. Prather and W.C. Westberry, the Cleburne store at 302 South Caddo Street still supplies a wide variety of feeds, seeds, and baby chicks—now available only in natural colors. (Courtesy of Layland Museum.)

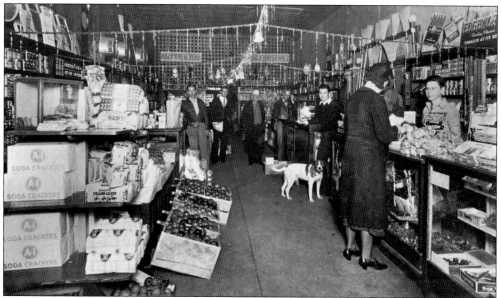

SOUTH MAIN GROCERY. Across from Market Square at 303 South Main Street was Head Grocery. Opened in 1926, the store stocked the basics, plus cigars, buckets of honey and molasses, lard, and ink, and it gave away water by the dipper. Shown here in the mid-1930s are, from left to right, Clyde Head, Vernon Head, an unidentified customer, M.R. Head, Charles Head (with his dog Buddy), customer Mae Horton, and Morris Head at the candy counter. (Courtesy of M.R. Head family.)

VENUS INCORPORATED IN 1903. The town was originally called Gossip until it developed in the 1880s. In 1888, a post office opened, and by 1890, Venus was at the junction of the International & Great Northern and the Gulf, Colorado & Santa Fe Railroads. By 1903, there were four gins, seven doctors, cotton buyers, barbers, and a fine hotel. (Courtesy of the Martin family.)

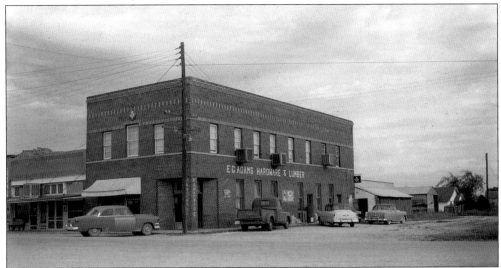

GODLEY, C. 1910. The Sylvester and Roy Hardware store preceded the Adams store (seen here) on the east side of downtown Godley. Other businesses operating about 1910 were Hudson-Davis Clothing, a livery stable, a drugstore, a grocery store, a post office, a bank, and a Masonic lodge. Land surrounding the town was home to about 35 ranches, including that of R.B. Godley, who owned a 1,900-acre farm and ranch. (Courtesy of Layland Museum.)

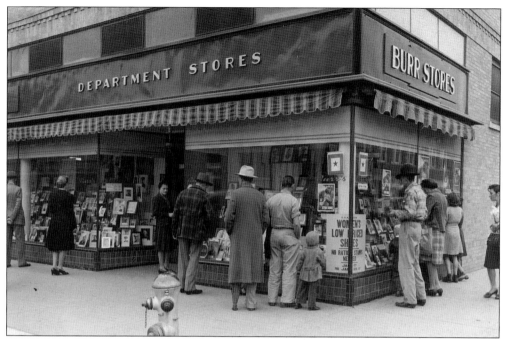

BURR'S HONORS THE MILITARY. During World War II, Burr's Department Store in Cleburne honored servicemen and servicewomen by displaying their images in its windows. A few years later, Levine's was located in this building at the corner of North Caddo and Chambers Streets. (Courtesy of Layland Museum.)

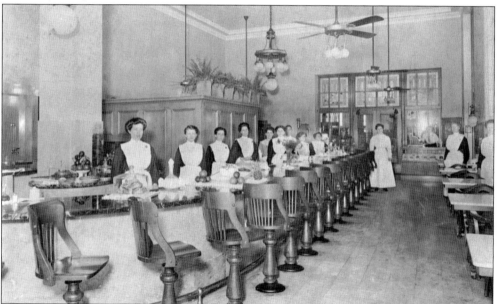

HARVEY HOUSE GIRLS. Waitresses, known as Harvey girls, lived above the Cleburne depot and worked in the restaurant downstairs. Fresh-baked bread, fresh fruit and vegetables, and pies made by local baker Zip Plemons were served to locals and those arriving by train. A brass gong was used to alert the staff when the train was approaching. The women wore black dresses and white aprons. (Courtesy of Layland Museum.)

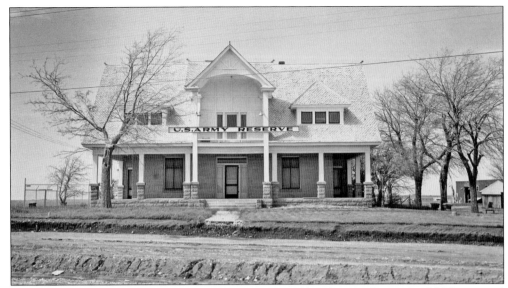

GATEWOOD HILL. Livestock dealer R.E. "Bob" Gatewood lived two miles south of Cleburne and shipped cattle by rail. His home, which still stands, became the US Army Reserve office in the mid-1950s. The Cleburne population in 1900 was 7,493; in 2010, it was about 30,000. (Courtesy of Layland Museum.)

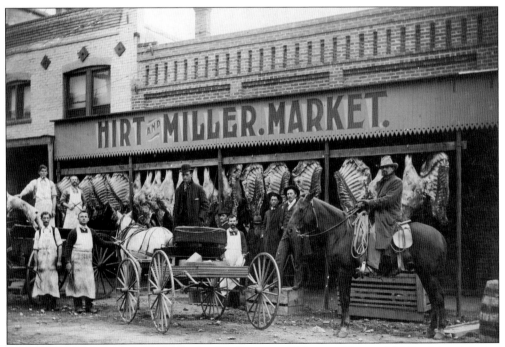

MEAT MARKET. Located on North Anglin Street in Cleburne, Hirt and Miller Meat Market opened in 1891. John Hirt and James Miller were the owners. Cattle brought from the Hirt Ranch was slaughtered at the store. The following year, the first telephone service began in town. The store's number was 26. (Courtesy of Layland Museum.)

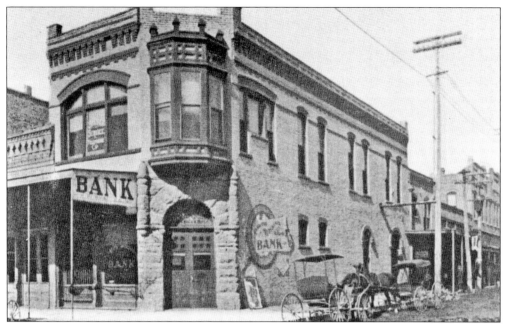

FARMERS AND MERCHANTS BANK. This building, which has housed several banks, began as Farmers and Merchants Bank. Jabe C. Smyth was the bank's president. Later, Citizen's Bank was located here. The first barbershop in Venus, owned by J.B. Carlisle, was located next door. A pair of bank robberies was filmed in Venus for the 1967 movie *Bonnie and Clyde*. Years earlier, the infamous couple actually did rob the town's two banks. (Courtesy of the Martin family.)

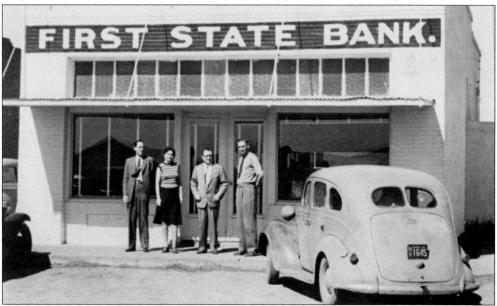

FIRST STATE BANK. Standing in front of the First State Bank in Rio Vista about 1946 are, from left to right, Doyle Ball, Nora Peyton, Lowell Smith Sr., and W.H. Smith. The bank was established in 1920. Under the direction of Lowell "Stretch" Smith, it became known as the Cow Pasture Bank, had fly-in service, and cared about its customers and employees. Smith Middle School in Cleburne was named in his honor. (Courtesy of Layland Museum.)

JERSEY ISLE OF TEXAS. Emmitt Brown (not pictured) was instrumental in the Rural Youth Dairy Program and in Cleburne becoming known as the Jersey Isle of Texas. At one time, Johnson County had more registered Jersey cattle than any other Texas county. Heifers were given away to youth, who in turn agreed to give back their first calf to keep the program going. Local Jersey Isle Dairy Stores sold the rich milk. (Courtesy of Layland Museum.)

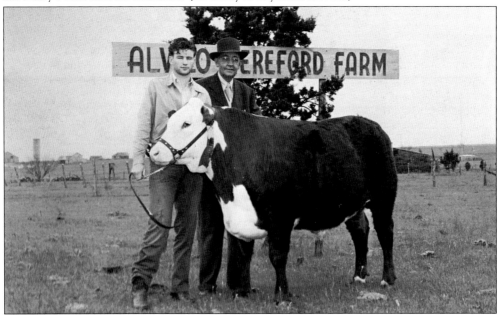

ALVILO HEREFORD FARM. Charles Styron (left), Future Farmers of America student and owner of a prize-winning Hereford, is pictured here with L.R. Coleman, purchaser. Coleman paid 40¢ a pound for the 1,100-pound Hereford at the annual Beef Calf Show. Coleman owned Coleman Motor Company and the Alvilo Farm just west of Yellow Jacket Stadium. (Courtesy of the L.R. Coleman Estate.)

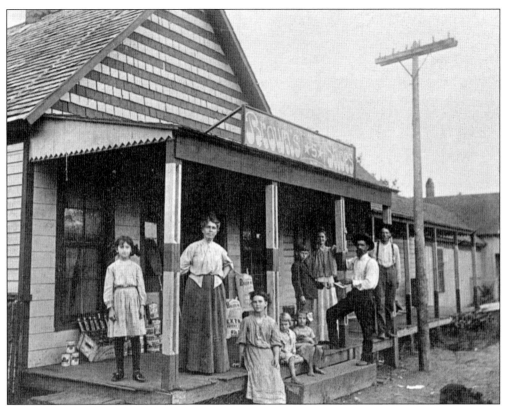

SAND FLAT STORE. J.M. Eller built a store that sold dry goods, groceries, and shoes. It was also home to the post office. Pictured here about 1905 are, from left to right, Erin Eller, Sopronia Eller, Mary Eller Alice "Totsy" Eller, and several unidentified persons. For decades, a small store and the Sand Flat Baptist Church have been the gathering places for locals. (Courtesy of Layland Museum.)

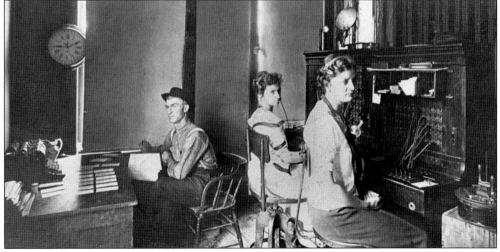

HELLO. THIS IS VENUS, TEXAS. Located upstairs in what would become the town's community center, the Venus telephone switchboard was operated by Madison Morton (center) and Ethel Morton. The man at left is unidentified. Rates were $2 a month for a business line and $1 for a residential line. (Courtesy of Layland Museum.)

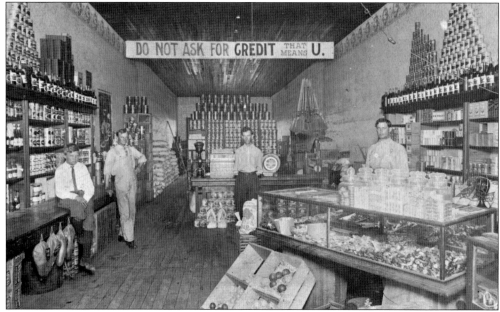

Do Not Ask. Most stores in the early 1900s operated on a cash-only basis. This grocery store, owned by R.B. Kimberlin, was no different. Other Cleburne groceries through the decades included Stewart's, Ball's, Williams, Dempwolf, Given's, Wofford's, Scott's, Meadows, Boston's, Edna's, Persons, McKinley's, Clarke's, Stephens, Stringer's, York's, Decolles, Wisdom's, Randolph's, and one of the first chain stores in town, Piggly Wiggly. (Courtesy of the M.R. Head family.)

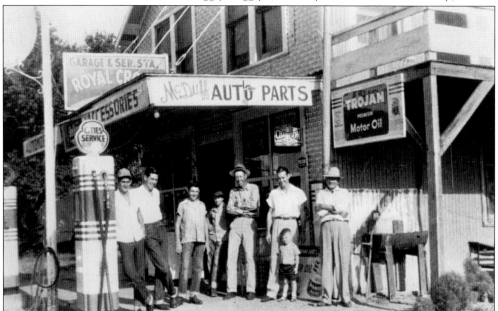

McDuff Service Station. Grandview was almost destroyed by fire in 1920. Pictured here in 1947 are, from left to right, Neil Kiker, Otis Hale, Barner Hale, Rex Pikes, J.H. Smith, J. Lang Smith, an unidentified child, and C. Jessie Smith outside the station. Rudolph McDuff became mayor of Grandview in 1961, just six years before another fire destroyed much of downtown. (Courtesy of Rudolph and Jessie McDuff.)

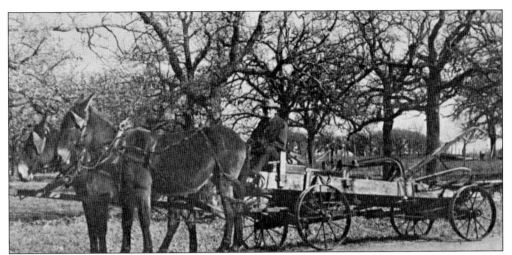

WAGON AND WORK. Enos Payne of Cleburne is seated on an old iron-wheeled wagon behind his team of mules. The wagon is loaded with a breaking plow and harrow, used to break gardens for local residents, once a common way of making a living. (Courtesy of Eddie and Betty Sewell.)

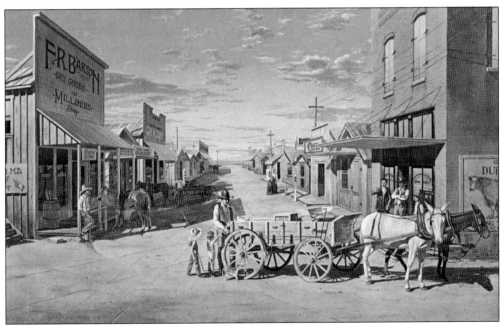

RIO VISTA, 1912. This painting by George Hallmark depicts the businesses on Rio Vista's Main Street. On the left is Barton Dry Goods and Millinery Shop, with an outside stairway leading to Dr. L.A. Colquitt's office. Next door is the Ball and Hart Grocery, then the Gatewood Grocery, which housed the Woodmen of the World upstairs. On the right is the Coffman & Lacewell Drug Store. The Noland's River Masonic Lodge No. 453 was upstairs. (Courtesy of Lowell "Stretch" Smith.)

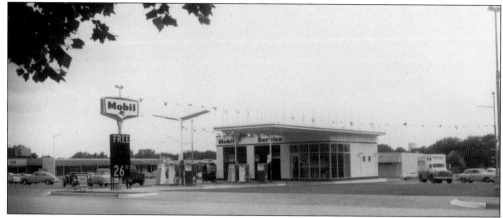

A Busy Corner. Cleburne Shopping Center on North Main Street was an active corner when Ben Franklin's, J.C. Penney's, Sears, Buddy's Grocery, and Roof Drug were thriving businesses there. Don Threadgill opened the Mobil station (shown here) in the early 1960s. Other owners were Olin Patterson and Luther Wilson. Across the street was Jose's Mexican Restaurant. (Courtesy of Layland Museum.)

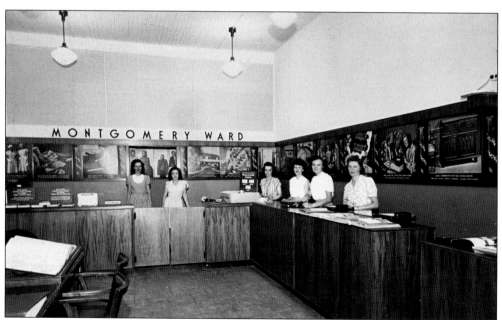

Montgomery Ward Downtown. Working at the catalog counter for Montgomery Ward in Cleburne in 1946 were, from left to right, Dorothy King, June Spikes, Dorothy Armstrong (manager), Zelma Beene, Edna Gaither, and Elizabeth Markus. The store was at 212 South Main Street. Its catalog was commonly referred to as the "Wish Book." (Courtesy of Zelma Beene.)

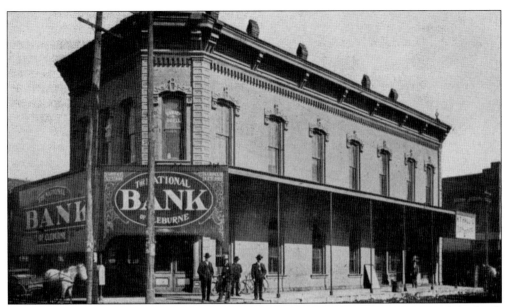

THE NATIONAL BANK OF CLEBURNE. W.F. Heard, S.B. Allen, and A.A. Barnes opened this bank in 1878 with a capital of $43,000. John Floore, S.E. Moss, and W.J. Rutledge were also involved in this institution, which was located on the southeast corner of the courthouse square. (Courtesy of Layland Museum.)

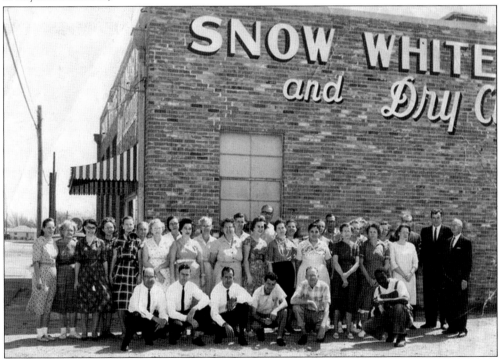

SNOW WHITE LAUNDRY. Lyman Filgo was a cotton buyer before he took over his father's laundry business at 205 Harrell Street in Cleburne. Working about 60 hours a week in the steam laundry as a bookkeeper in 1940, Filgo learned the trade and operated a successful company that employed dozens of people. Ogle Ford was the delivery driver. (Courtesy of Layland Museum.)

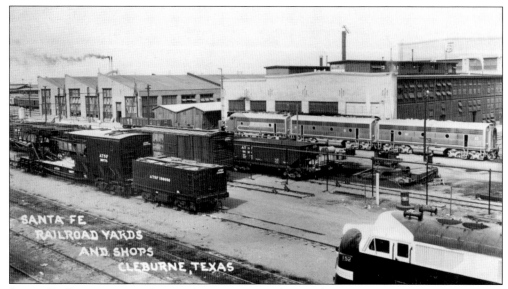

SANTA FE RAILROAD AND SHOPS. Over 1,000 people met the first train to enter Cleburne in 1881. By 1902, Santa Fe had invested over $600,000 and had a monthly payroll of $40,000. The railroad employed about 1,400 people. Diesel freight came to town in 1945, and Cleburne became a major repair location. Many areas of the shops were updated or built during the 1970s and 1980s. (Courtesy of Mollie Mims.)

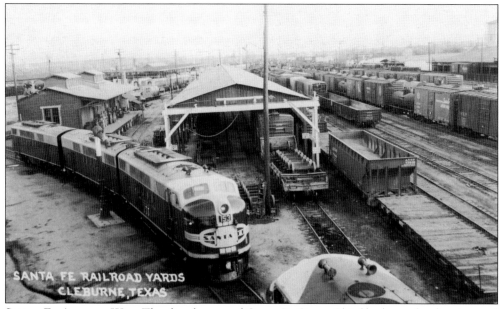

SANTA FE ALL THE WAY. The diesel-powered Santa Fe Super Chief had cars for sleeping and dining, as well as an observation car, all decorated with a Southwestern flair. It ran for 35 years before Amtrak took over operations. The apprentice school began in 1950 and included 1,600 hours of instruction. By the mid-1980s, the Cleburne shops employed 750 people and had an annual payroll of $21 million. (Courtesy of Mollie Mims.)

RIO VISTA DRUG. The Coffman family opened their first drugstore in 1898. They also sold general merchandise and groceries and operated a fountain. After a fire destroyed the building in 1914, Mr. and Mrs. C.H. Coffman erected a two-story building, with his store on the first floor and the Masonic lodge on the second floor. The contents of the business were sold to Roof Drug in 1964. (Courtesy of Layland Museum.)

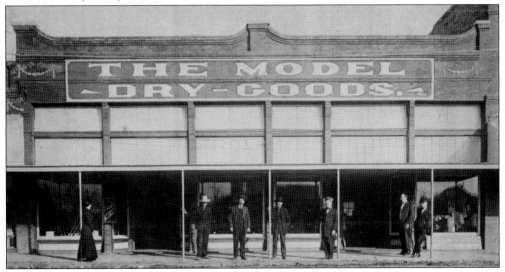

THE MODEL IN VENUS. Posing in front of the Model Dry Goods store are, from left to right, Mrs. W.C. Briggs, two unidentified, Mr. Nigos, Dee Shytles, W.C. Briggs, and Dorman Allen. In 1904, the business had a special opening to show off its fine fall millinery. Other stores about 1900 on the north side of the square were Renfro Hardware, Charles Gidden Grocery, Singleton and Poteet Grocery, and Shytles Drug. (Courtesy of the Martin family.)

People Who Make Enterprise.

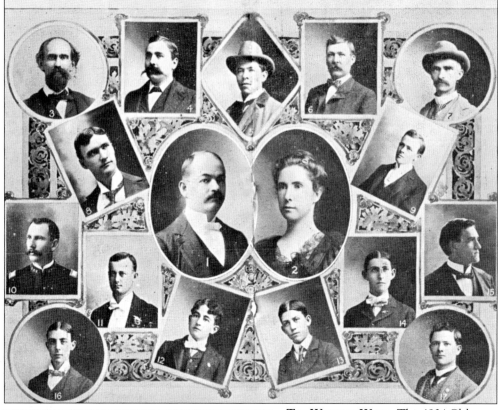

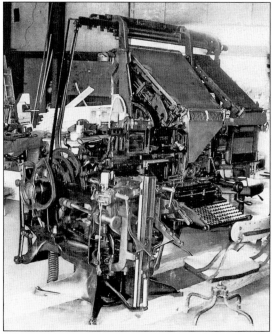

THE WRITTEN WORD. This 1904 *Cleburne Enterprise* staff image was in the Layland Museum time capsule opened in 2013. Pictured above, as numbered on the image, are the following: 1. John R. Ransone Jr. (editor), 2. Sally Elizabeth Ransone, 3. John Ransone, 4. George W. Fisher, 5. Oatis H. Poole, 6. N.A. Adams, 7. F.N. Graves, 8. James E. Pitts, 9. U.A. Anderson, 10. J.C. Bridges, 11. T.E. Harper, 12. A.P. Ransone, 13. Louis Marsden, 14. Sitwell Prescott, 15. W.F. Black, 16. Wilie Gerstenkorn, and 17. Lovick Adair. The Linotype machine at left was used to set up and print the *Burleson Dispatcher* until it closed in 1985. The printing press, which allowed the type to be chosen and cast in metal, was restored by Robert Griffith and is now located in the Burleson visitors center. This building was originally the Loyless Drug Store and interurban ticket office. (Above, courtesy of Burleson Historical Foundation; left, courtesy of Layland Museum.)

Four

GETTING AROUND

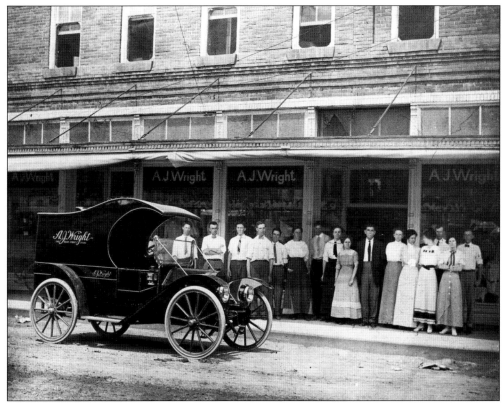

FIRST TEXAS CAR COMPANY. Cleburne distinguished itself not only in Johnson County but in all of Texas when Rev. Henry Eugene Luck began the first Texas car manufacturing company, the Cleburne Motor Car Company. The 1910 Chaparrel had solid rubber tires and a 20-horsepower, air-cooled engine. The Luck Truck (shown here), purchased by A.J. Wright for making deliveries, was the third vehicle produced. (Courtesy of Layland Museum.)

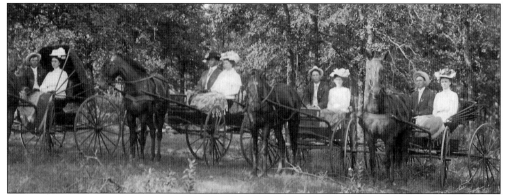

OUT FOR A RIDE. It was January 1907 when these friends and relatives near Alvarado went for an afternoon ride. Shown here sitting in their buggies are, from left to right, Hiram and Ethel McAlister Crow, Jim McAlister and Annie Griggs, Alvin and Daisy Crow, and Sam and Ina Fowler. (Courtesy of Judy Nolen Slater.)

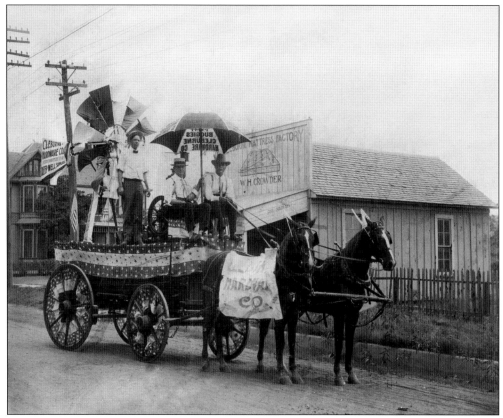

DECORATED FOR A PARADE. This wagon, advertising Cleburne Hardware Company, is ready for a parade around 1910. Selling deep-well supplies, hardware, and farm items, the business opened in 1889 on South Main Street. Many buggies and wagons were also sold, making family traveling easier. Crowder Mattress Factory, at 508 South Main Street, was owned by William H. and Martha Crowder. (Courtesy of Layland Museum.)

50

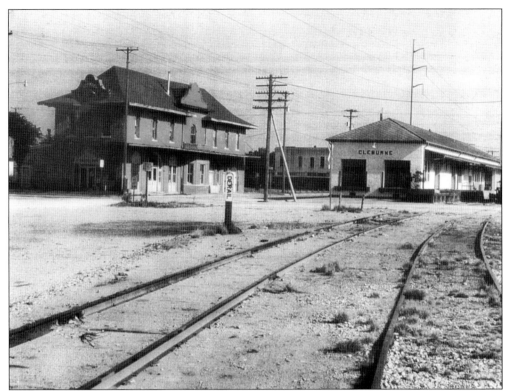

DEPOTS IN CLEBURNE. Known as "the Boll Weevil," after the destructive cotton parasite, the Trinity & Brazos Valley Railroad came to town in 1904. Its shop facilities were situated on the future site of Hulen Park. The Santa Fe Railroad depot (right) was torn down when the overpass was constructed in 1993. (Courtesy of Layland Museum.)

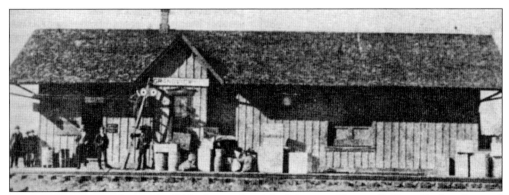

GRANDVIEW ON THE GROW. In 1882, the tracks of the Missouri, Kansas & Texas Railroad passed within two miles of Grandview. Residents and businesses began moving south to be near the rail line. By 1860, a townsite was laid out, and in December, a two-story building was completed. The county's first Masonic lodge held its meetings in the building, and the town's first school conducted its classes there. (Courtesy of Rudolph and Jessie McDuff.)

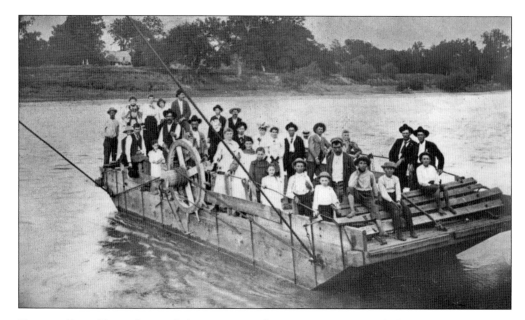

KIMBALL BEND FERRY. Pictured above crossing the Brazos River at Kimball Bend about 1890 are Essie Claggett Gardner, Dimple Claggett Carruthers, Cordelia Claggett deCordova, Tom Claggett, William M. Cleveland, Dave Alsup, Leonard Alsup, Lillian Cleveland, Julia Fletcher, William Oscar Hammond, Luna Hollinsworth Boggs, Mollie Alsup Waddell, Ross Willingham, Robert L. Hollinsworth, Hillard Boggs, Turney Mitchum, Elmo Alsup, Bud Alsup, John Alsup, Gertrude Goddard Alsup, Lula Cleveland Rogers and Emmitt Willingham and three unknown riders on the front right. By swift current and cables, even wagons were loaded to cross the river (below). The cost per wagon with a team of horses was 25¢; buggy or on horseback, 25¢; and individual on foot, 10¢. It is believed that cattle was herded across this same area on the Chisholm Trail southwest of Rio Vista. (Both, courtesy of Layland Museum.)

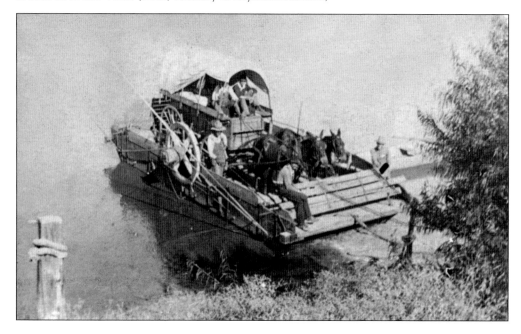

AIRSHIP OVER CLEBURNE. Cleburne native Charles Rosendahl commanded the USS *Akron* over his hometown in 1932. At 785 feet long, the helium-filled airship had a crew of 82 and could store 20,000 gallons of gasoline. Rosendahl, who also commanded the USS *Los Angeles*, retired as a vice admiral. His extensive collection of memorabilia is available at the University of Texas at Dallas. (Courtesy of Layland Museum.)

OVERLAND TOURING CAR. For just over $1,000, an open-style automobile was purchased in 1912. The five-passenger car came complete with black leather upholstery, 30-horsepower engine, gas side lamps, three speeds and reverse transmission, and a 106-inch wheelbase. A mohair top and glass windshield were an additional $50. Side curtains could be hung and pulled shut to aid in weather protection. (Courtesy of Lulane Ward.)

Overland Automobile Co. of Dallas

DALLAS, TEXAS

July 1, 1912 No. A 256

Sold to: H. Peoples,

(J A Shaw, Lillian, Texas)

Address: Burleson, Texas.

Agency:

ALL CLAIMS MUST BE MADE WITHIN 5 DAYS OF RECEIPT OF GOODS

Their Order No. Date

TERMS: Net Cash

Shipped via Checked by

MODEL	NAME	TYPE	NUMBER	LIST	NET
59	Overland	touring	59	900.00	
		freight		65.00	
		top and shield		50.00	
PUMP		top boot		5.00	
JACK & HANDLE		large lamps		5.00	
TIRE REPAIR KIT		oil & gas		2.00	
ROLL OF TOOLS		chains		5.50	
CYLINDER PLUG WRENCH		2 32x3-1/2 inner tubes		9.00	
HUB CAP WRENCH		1 #11 Stewart speedometer		27.50	
ROLL SIDE CURTAINS		1 Search-light tank		25.00	
CAN OIL (LUB).				1094.00	

53

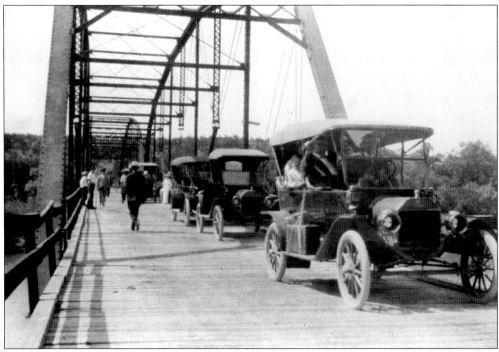

Bridge over the Brazos River. This 1914 photograph shows opening day of the new bridge at Brazos Point, which joined the southwestern edge of Johnson County with Bosque County on County Road 1118. Today, pedestrians walk the bridge, which is almost 800 feet in length. Automobiles use a new bridge built beside it. The Baker Lain Cemetery is nearby. (Courtesy of Layland Museum.)

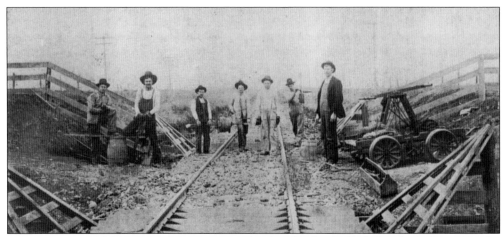

Laying Track. Cleburne was home to several railroads: the Gulf, Colorado & Santa Fe; the Trinity & Brazos Valley; the Chicago, Texas & Mexican Central Railroad; and the Dallas, Cleburne & Southwestern Railroad. In Alvarado, two lines crossed: the Gulf, Colorado & Santa Fe and the Missouri, Kansas & Texas. The towns of Joshua and Rio Vista were served by the Gulf, Colorado & Santa Fe. Parker was connected with the Trinity & Brazos Valley. (Courtesy of Layland Museum.)

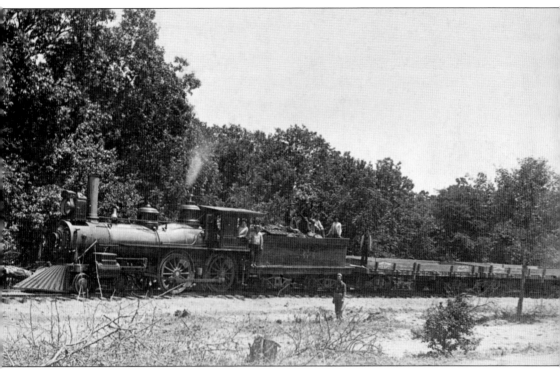

GULF, COLORADO & SANTA FE. Engine No. 38, a 4-4-0 (representing the arrangement of the wheels and axles), is seen in the Cross Timbers area of the county transporting flatcars. This engine, with a tall smokestack, is the same kind that first pulled trains across Johnson County in 1881. Passengers rode on these flatcars until actual passenger cars began service to this area in 1882. Settled about 1853, Cross Timbers was named for its location on the edge of the western Cross Timbers. A post office opened in 1870. By 1885, the population was 100, and the town had a school, church, cotton gin, and gristmill. In 1896, the school had an enrollment of 25 students, but by 1900, the school had closed. Both the Missouri, Kansas & Texas and the Gulf, Colorado & Santa Fe lines bypassed the settlement in the 1880s. The Cross Timbers Post Office closed in 1904. The town of Cross Timber, incorporated in 1991, is located about 10 miles north of Cleburne between State Highway 174 and Farm Road 731. (Courtesy of Michael Percifield.)

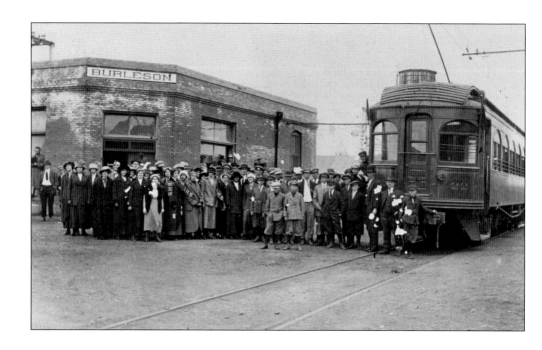

BURLESON INTERURBAN TRAINS. From September 1, 1912, to April 30, 1931, the Northern Texas Traction Company operated a trolley-type electric interurban railway from Fort Worth through Joshua to Cleburne, providing daily regularly scheduled passenger and express service. Occupied by the Burleson Heritage Foundation today, the Loyless Interurban Drugstore building pictured above boasted the first concrete floor and electric lights in town. In later years, it served as the town's newspaper office. On opening day (pictured above), some 1,200 passengers paid the 88¢ fare for a round-trip ticket. During the line's 19 years of service, 8,266,000 people rode in cars like the restored No. 411, pictured below on display in Burleson. Countless shipments reached their destinations via the interurban express on restored car No. 330. Customers could flag down the cars anywhere along the way or board at designated stations. (Both, courtesy of Burleson Historical Foundation.)

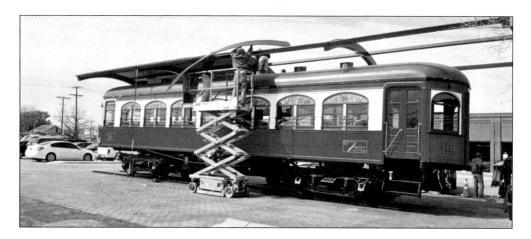

RIO VISTA BY AIR. In 1969, mesquite trees were removed west of Rio Vista State Bank, and the first fly-in customer landed. Bank employees posed for annual Christmas cards on the landing strip. Jessie Fantroy baked and served cookies to customers for many years, and Pop Myers provided chili for their annual Western fiesta and helped with publicity. (Courtesy of Layland Museum.)

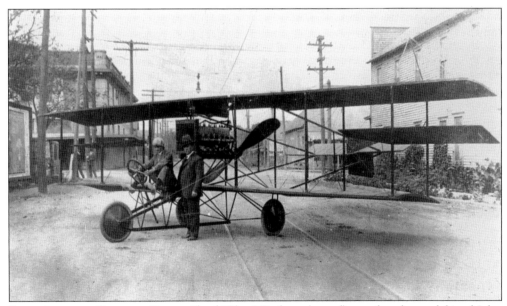

FIRST AIRPLANE BUILT IN TEXAS. Floyd "Slats" Rodgers (seated), a railroader, and friend John C. Fine (standing) built this plane in 1912. The plane was named "Old Soggy" because of a persistent droop in one wing. They began construction in Cleburne and completed it in Ed Wallen's blacksmith shop in Keene. The Hopps Museum in Keene is home to a half-sized replica. (Courtesy of Layland Museum.)

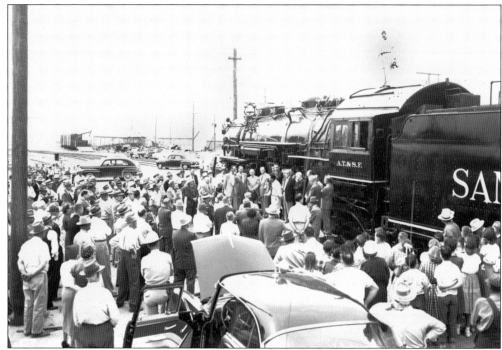

3417'S NEW HOME. Santa Fe steam engine No. 3417 was moved from the tracks south of downtown Cleburne to Hulen Park a few blocks away in 1955. The engine was built in 1919 and ran until 1954, taking passengers from Cleburne to Purcell, Oklahoma, and transporting US military troops during World War II. It logged over two million miles. (Courtesy of Layland Museum.)

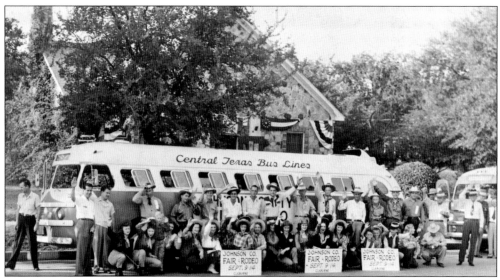

CENTRAL TEXAS BUS LINES. George Hyde purchased a bus line and began operations in 1933 as Central Texas Bus Lines. The name was changed to Central Texas Trailways in 1960. Busses ran all four directions out of Cleburne, and charter busses took groups to events. In this photograph, folks prepare to ride to the annual Johnson County Fair and Rodeo. (Courtesy of Layland Museum.)

Five

SPIRITUAL GROWTH

GROWING UP IN CHURCH. Typical of most Baptist churches, Bono Baptist held Sunday school classes, Training Union classes, and other activities for the religious education of children. Shown here around 1959 are, from left to right, Timalene Baker, Phillip Jones, Brenda Brand, Becky Brand, unidentified, Melinda Jones, Joyce Morris, Nell Brand, and Janice Morris. (Courtesy of Bono Baptist Church.)

ALVARADO CONGREGATIONS. The Methodist, Christian, Cumberland Presbyterian, and Baptist churches each had a circuit-riding minister who preached on rotating Sundays. The first place of worship in Alvarado was a log cabin, which was also used for a school. The church pictured was completed about 1887 (after the first church burned) on land donated by the Gulf, Colorado & Santa Fe Railway Company. (Courtesy of Michael Percifield.)

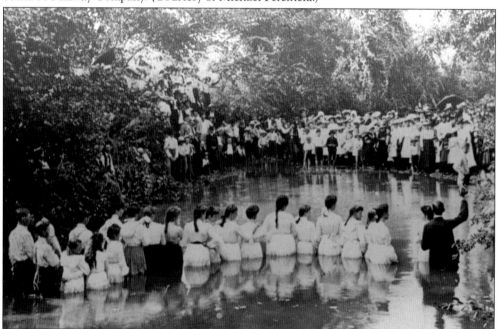

BAPTISM IN VILLAGE CREEK. Boothe Hole on Village Creek was the site of many baptisms. Here, Reverend McDonald (first row, far right) and visiting evangelist Dr. J. Frank Norris conduct a group baptism. The creek begins east of Joshua and flows for 34 miles. The C.C. Moore place, east of Egan, was another popular baptizing hole. (Courtesy of Layland Museum.)

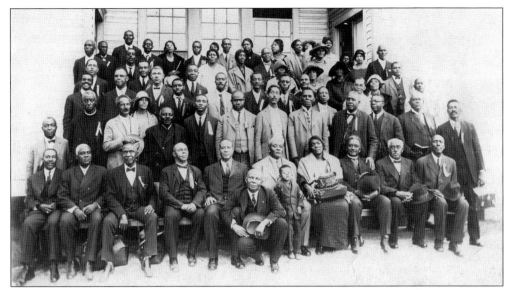

A Church on the Move. Established in 1887 by the Goodwin and Sims families and named for Bishop Moses Salter, the first Salter Chapel African Methodist Episcopal Church building was on East Chambers Street in Cleburne. A sanctuary was erected on Brazos Street in 1918 where the annual conference pictured above was held. The sanctuary was relocated to 106 Olive Street in 1926 on land donated by the Charles Alexander family. Funding came from the Grand Lodge Colored Knights of Pythias of Texas. Greater Bethel AME Church was formed in nearby Oak Hill. The churches, experiencing declining membership, officially merged in 1988 under the name Bethel Salter AME Church. Below, employees of the Otto McLeroy House Moving Company of Alvarado prepare the wooden church for its Olive Street location in 1926. (Both, courtesy of John Warren.)

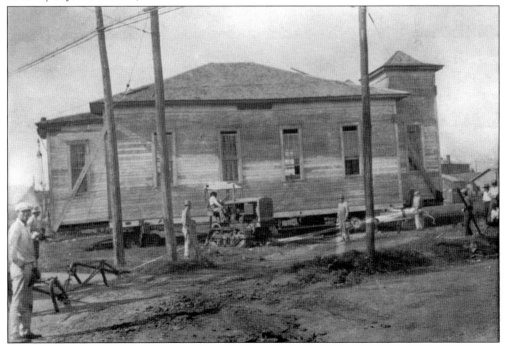

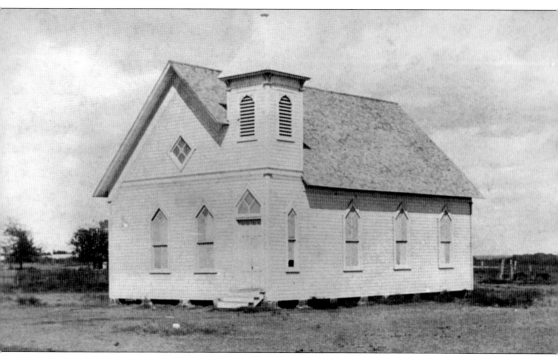

FIRST METHODIST BURLESON. Built in 1895, First Methodist Church Burleson was also home to several organizations. In 1962, a new sanctuary was built, and the wooden one shown here was torn down. A third location, on Renfro Street, became home to the church in 1971. The current church opened on McAlister Road in 2002 and includes a bell tower. In 2006, the congregation merged with Kingswood United Methodist. (Courtesy of Burleson Historical Foundation.)

SOUTHERN BAPTISTS IN CLEBURNE. First Baptist Church Cleburne has its roots in a meeting in May 1868. This redbrick church was completed in 1878. The congregation aided in the start of new churches, including East Cleburne (now know as Henderson Street, 1897), Field Street (1911), North Cleburne (1905), College Heights (1953), and Nolan River Road (1988). La Primera Iglesia Bautista Emanuel began as a Sunday school class in 1976. (Courtesy of Layland Museum.)

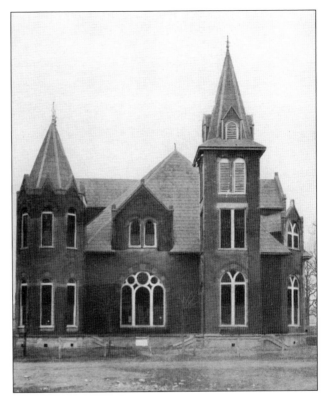

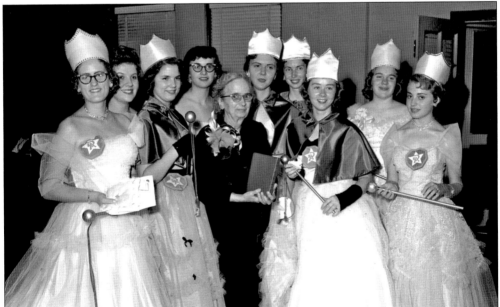

GIRLS' AUXILIARY. This is a coronation service of a girls' missions study group at Field Street Baptist Church. When the church began, it was known as the West Side Mission. The first pastor was Rev. Charles Pitts Sr. Shown here about 1958 are, from left to right, Ann White, Janey Hazlett, unidentified, Shirley Matthew, Seneth Woods (teacher), Lynda Bateman, Janice Payne, Hazel Ruth Bell, Dolores Banks, and Ann Dawson. (Courtesy of Layland Museum.)

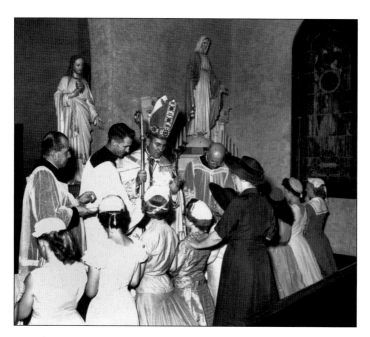

ST. JOSEPH CATHOLIC CHURCH. St. Joseph Parish was established in 1888 by a missionary priest. Parishioners met in a frame church at the corner of Wardville and Wilhite Streets in Cleburne. The church burned down 10 years later, and a new one was built in the 800 block of North Anglin Street. In this photograph, Bishop John J. Cassata gives the sacrament of confirmation to young church members. (Courtesy of Layland Museum.)

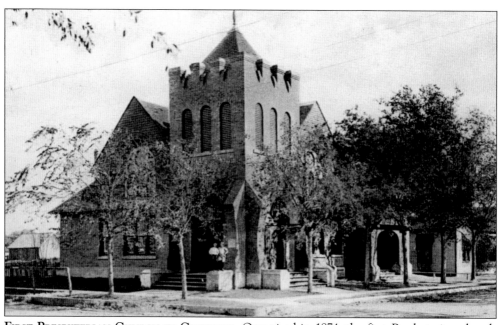

FIRST PRESBYTERIAN CHURCH IN CLEBURNE. Organized in 1874, the first Presbyterian church (shown here) was built by E.J. Zimmerman at the corner of North Main and Heard Streets in 1904. The memberships of the church and that of Anglin Street Presbyterian Church voted to combine congregations, adopting the name United Presbyterian Church. The congregants began meeting in their new sanctuary on Nolan River Road in 1978. (Courtesy of Layland Museum.)

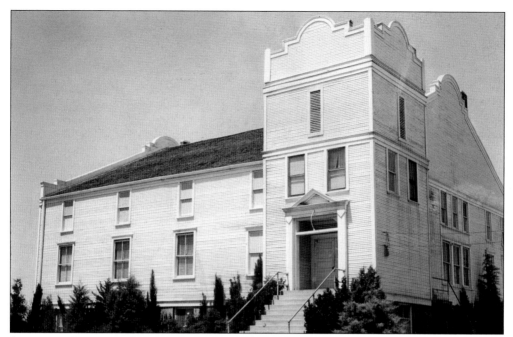

ADVENTIST CHURCH IN KEENE. In 1894, 67 people met between Alvarado and Cleburne and signed their names as charter members of the Keene Seventh-Day Adventist Church. Services were held on the campus of the newly founded Keene Industrial Academy. In 1905, the church moved into a meeting hall. The current facility was constructed in 1956. Later additions included a Sabbath school and chapel, youth center, and office space. (Courtesy of Southwestern Adventist University.)

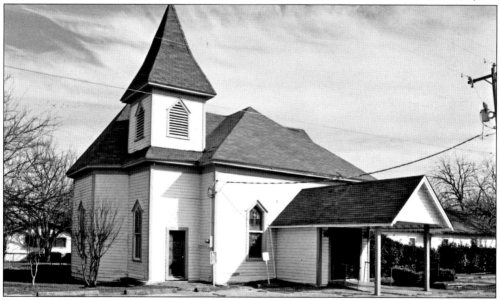

RIO VISTA UNITED METHODIST. Confederate veteran James Cooper helped fund the Methodist Episcopal church South, now known as the United Methodist church. Community volunteers donated the labor. Circuit rider Brother Kiker was there for its completion in 1907. Before air-conditioning, summer revivals were held in the Baptist or Church of Christ tabernacles. A parsonage was added east of the church in the 1960s. (Courtesy of Mollie Mims.)

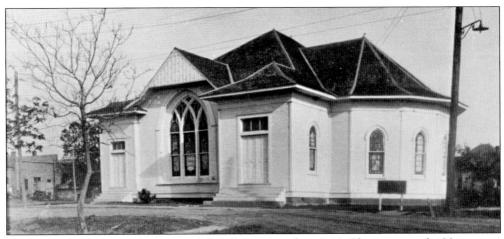

FIRST BAPTIST CHURCH IN VENUS. Officially organized in 1896, Christians in the Venus area began meeting earlier a mile west of the town's present-day location. About 1894, the church, post office, and a store were moved to town. The congregation combined with the Missionary church in 1912. In the early years, the Baptist and Methodist pastors preached on alternate Sundays. (Courtesy of Layland Museum.)

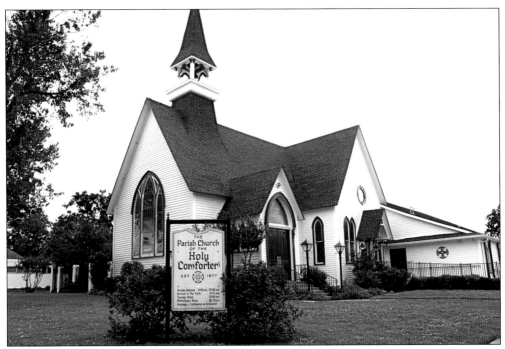

EPISCOPALIAN PARISH IN CLEBURNE. The Church of the Holy Comforter, at the corner of Anglin and Wardville Streets, was completed in 1893 under the leadership of Rev. W.W. Patrick. Formed in 1871, this was the first parish in Johnson County. The nave is preserved in its original state. The parish hall was added in 1905 and remodeled in 1985. (Courtesy of Mollie Mims.)

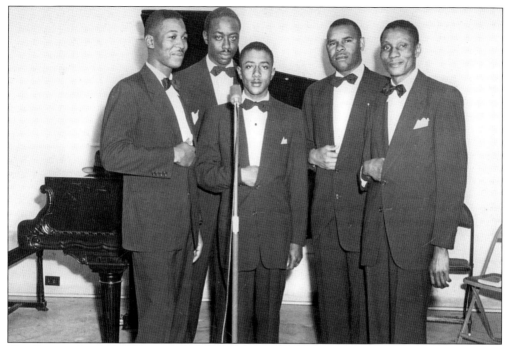

THE GOSPEL AIRES. For about 20 years beginning in the late 1940s, these friends sang traditional gospel songs a cappella all over North Texas. On Sunday mornings, they preformed live on KCLE radio. The singers are, from left to right, Alfred Johns, Frank Overton, Jerome McNeil Sr., Clarence Casmer, and Moses Jackson. They were members of the Booker T. Washington School class of 1936. (Courtesy of John Warren.)

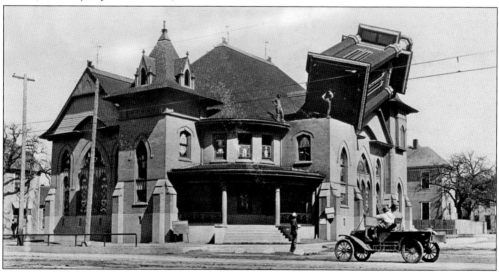

MAIN STREET METHODIST. The B.J. Chambers family donated three lots in Cleburne for the construction of Cleburne Methodist Episcopal Church, South, in 1869. Horse-drawn vehicles moved parts of this original structure to Main and Brown Streets (pictured), where Main Street Methodist Church was constructed in 1902. Shown here, they are working on setting the steeple. The congregation moved to a new building, First Methodist Church, in 1966. The term "United" was added in 1968. (Courtesy of Layland Museum.)

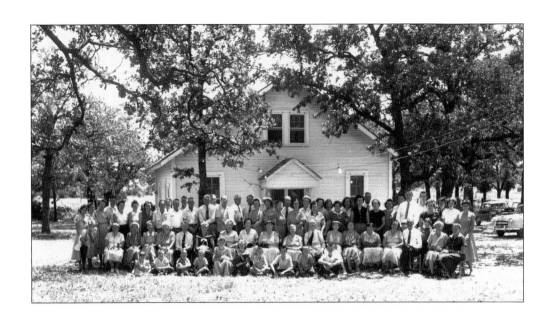

EARLY BAPTIST CHURCHES. Pioneers settled at the head of Crill Miller Creek, meeting one Sunday a month for worship in the home of J.W. Rawls. From this group, the first Baptist church in Johnson County was organized in 1855. Located about six miles southeast of Burleson, the members named it Bethesda Baptist Church. In 1873, David R. Jackson donated land, and a large one-room structure was built at the current site. The above photograph was taken at the church's 100-year anniversary celebration. The below photograph shows New Hope Baptist Church, located between Baker Lane Cemetery and the Goatneck community. It was organized in November 1860. Originally named the Mars Hill Baptist Church of Christ, it was led by Rev. Louis Bald. (Above, courtesy of Layland Museum; below, courtesy of Larry Mims.)

LILLIAN BAPTIST CHURCH. This congregation had its beginning in 1870 as Pleasant Point Baptist Church, located about two miles southeast of Lillian. W.B. Senter was the first called pastor. The International & Great Northern Railroad began laying track in 1902, and the church building was moved in 1904 to the new community of Lillian. The name did not change until 1968. Pictured is the church in 2013. (Courtesy of Mollie Mims.)

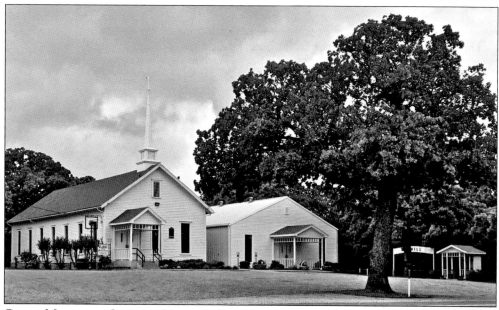

CAHILL METHODIST CHURCH. A community grew up around the Nancy and Aquilla Cahill farm after they settled it in 1859. Sarah E. Snodgrass donated land for a Methodist church and cemetery in 1893 in memory of her father, Aquilla Cahill. Church members built the sanctuary and tabernacle, and the congregation was served by circuit-riding ministers. (Courtesy of Larry Mims.)

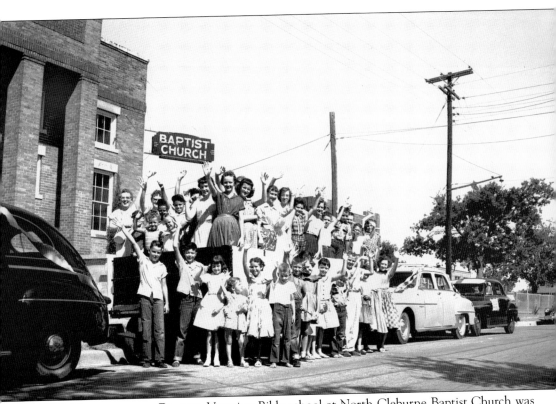

VBS Neighborhood Parade. Vacation Bible school at North Cleburne Baptist Church was booming in the 1950s. Cars and trailers were decorated, children piled in, and adults drove through the surrounding neighborhood, honking horns and inviting children to attend. Bible stories, crafts, music, and marching into the worship auditorium to the tune of "Onward Christian Soldiers" were part of the routine. The two-story church shown here, fronting North Robinson Street, was completed in 1919. A new auditorium was built in 1959, and the older building was remodeled. (Courtesy of Layland Museum.)

Six

GATHERING PLACES

KLONDIKE RANCH TREASURE. Located on the winding Brazos River in southwestern Johnson County is this historic property. The 1,000-plus-acre ranch, once owned by a nephew of Gen. Sam Houston, is still privately owned. The stone home, constructed about 1935 and restored in 1991, has 22-inch-thick walls. The ranch includes Fern Cave and 1.8 miles of river frontage. (Courtesy of the L.R. Coleman Estate.)

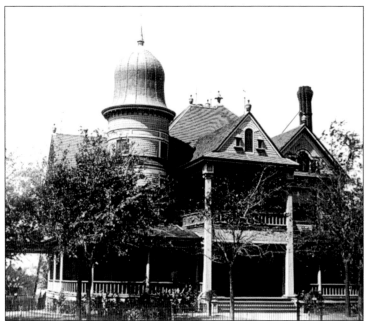

PITTMAN FAMILY HOME. Built in 1900 and torn down in 1959, the M.M. Pittman home stood on the corner of North Main and Williams Streets. The 16-room residence had hand-carved wood trim, 12-foot ceilings, brass doorknobs, and seven fireplaces. The family hosted many elaborate parties for as many as 400 guests. The Pittmans owned a grain-milling company in Cleburne. (Courtesy of Layland Museum.)

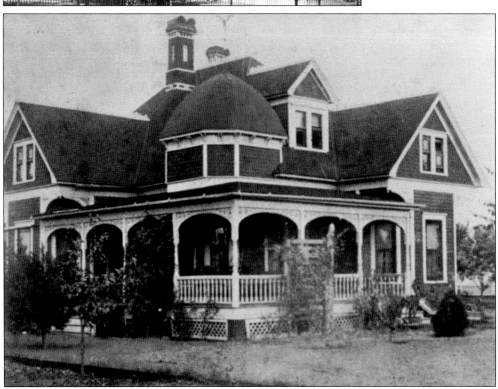

HAYDEN HOME. Merchant and physician G.W. Hayden and his family thrived during Grandview's growth and its incorporation in 1891. Their ornate home, shown here, was among the 90 destroyed by fire in 1920. At the time, Grandview was a town of 1,500 residents. The blaze also claimed 45 businesses. Farmers with wagons and mules helped clean away the debris, and the community began to rebuild. (Courtesy of Rudolph and Jessie McDuff.)

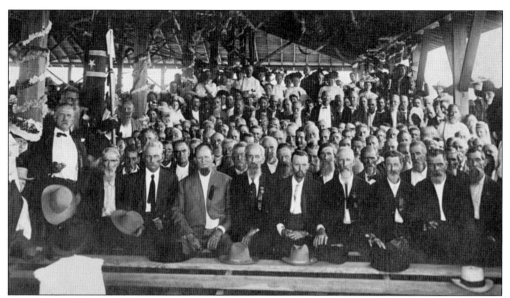

JOHNSON COUNTY REUNION. In 1893, the Johnson County Pioneers' and Old Settlers' Association was organized. The group of Civil War veterans seen here is meeting in Alvarado at the 1907 reunion. Initially held in different areas of the county, the reunion's permanent location became Alvarado in 1899. A fiddlers' contest, parade, and baby contest are now part of the annual festivities. (Courtesy of Layland Museum.)

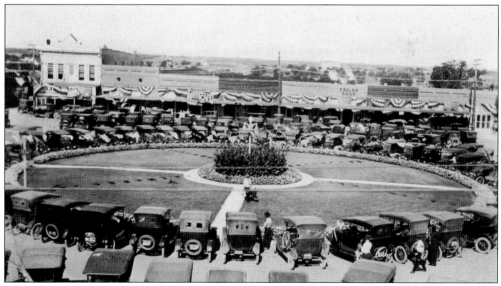

CENTER OF ACTIVITY. In this photograph, band members and local citizens gather around the circle in downtown Alvarado. Thriving businesses included Brown's Barber Shop, Perkins Creamery, the Alvarado Bulletin, Leary's Drug Store, Fern's Sandwich Shop, Alvarado Theatre, Johnston Grocery, and the City Café. A historical marker and gazebo are now in the circle. (Courtesy of Layland Museum.)

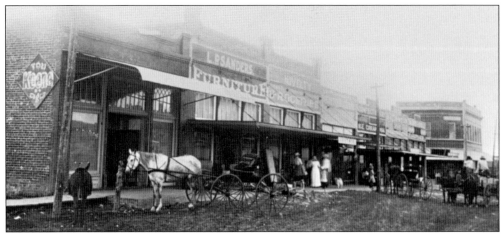

VENUS, WEST SIDE. A movie house, Sanders Furniture, Simpson Confectionery, a pool hall, Dr. J.T. Shyles's office, and a grocery store drew locals to the west side of the square. A fire destroyed this section of town in 1910, and it was rebuilt by the following year. Streets around the square were paved about 1920. (Courtesy of Layland Museum.)

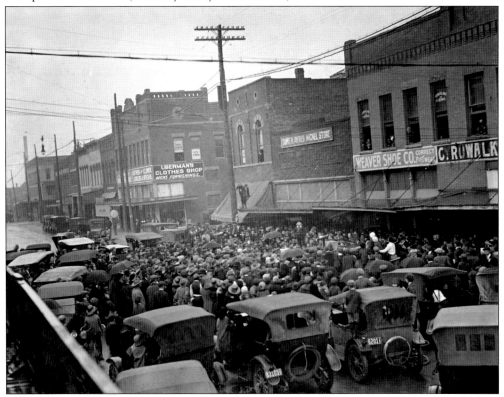

BUSTER BROWN VISITS CLEBURNE. The company mascot of Buster Brown Shoes traveled the country, promoting shoes and drawing huge crowds everywhere he went. Seen here right of center, in front of Cleburne's Weaver Shoe Company, a little person complete with a pageboy haircut portrays Buster Brown some time before 1920. Next door was Duke & Ayres Nickel Store. Above many of the downtown merchants were offices for doctor and lawyers. (Courtesy of Layland Museum.)

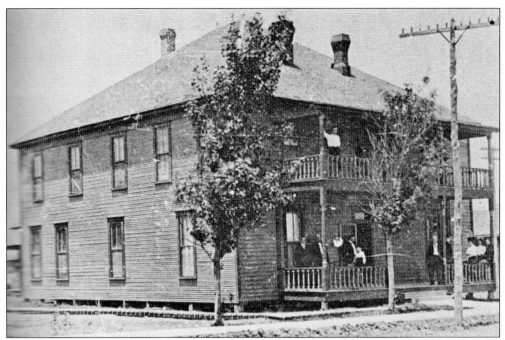

VENUS HOTEL. The Venus Hotel stood near the depots of the Gulf, Colorado & Santa Fe and the International & Great Northern Railroads. The town of Venus, first called Midway, moved to its present location when the railroads arrived. The fertile blackland prairie included deep artesian wells. Captain Hill had a racetrack three miles south of town. (Courtesy of Layland Museum.)

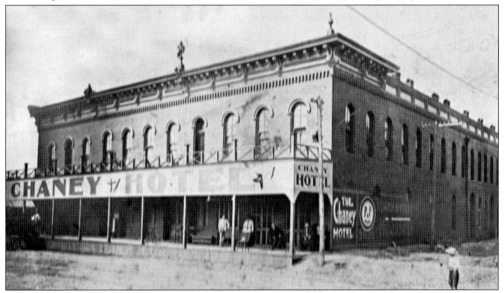

CHANEY HOTEL. The Hamilton House opened on East Henderson Street in Cleburne in 1874. William Robert Chaney purchased the company in 1906, changed the name, and provided accommodations for railroad crews. The Chaney Hotel is seen here about 1920. Other overnight accommodations included the Oriental Hotel on West Chambers Street, the New Murray Hotel, the Globe Hotel, the Porter Hotel, and the Tennessee House, operated by Sally Smith. (Courtesy of the Wilburn Chaney family.)

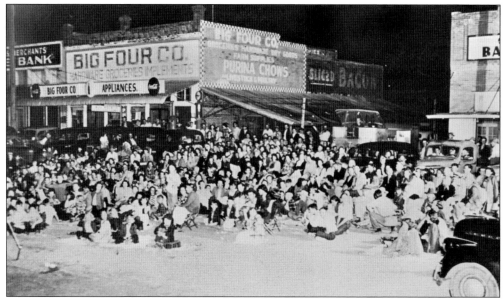

FREE MOVIES IN BURLESON. In this 1949 photograph, families gather in the downtown streets of Burleson to watch free movies. To this day, people still gather downtown—in restaurants, offices, and retail businesses and for free concerts. Burleson's population in 2010 was 36,690, making it the largest town in the county. (Courtesy of Burleson Heritage Foundation.)

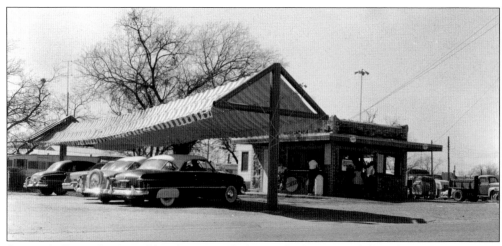

SHIFTAR'S DRIVE-IN. Donald and Margie Shiftar made their own chili and root beer for their popular drive-in hot dog stand on West Henderson Street in Cleburne. They special-ordered the hot dogs. Neatly dressed carhops took orders for chili cheese dogs and frosted mugs full of root beer. On some days, as many as 1,000 dogs were sold. (Courtesy of Layland Museum.)

HAMM CREEK PARK.
Constructed in the 1950s as part of the Lake Whitney development, then used as a recreational area for the families of service members stationed at Carlswell Air Force Base, this campground closed in 1990. Now operated by Johnson County, it reopened in 2007 after a complete renovation. The movie *Indian Paint* was shot on location near this park in 1964–1965. (Courtesy of Mollie Mims.)

CLEBURNE STATE PARK. Comprising 528 acres, this densely wooded state park has been a favorite camping area since Civilian Conservation Corps Company 3804 built a dam and three-level spillway to form the spring-fed Cedar Lake. A boathouse, bathhouse, and concession building were finished in 1936. Cabins, a group dining facility, a store, screened shelters, 58 campsites, fishing and swimming areas, and hiking trails contribute to the park's popularity. (Courtesy of Sandra Davis Jones.)

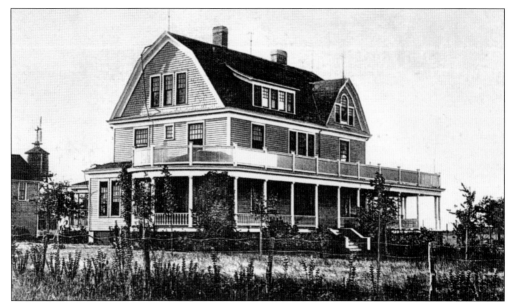

BELVEDERE HOME NEAR CONCORD. This lovely home, which included a basement, was one of three located off Highway 171 between Godley and Cleburne. Belvedere was the name given to the home and ranch, owned by S.M. Hill and later purchased by Dewey C. James Sr. At one time, James farmed 14,000 acres, including this area. (Courtesy of Layland Museum.)

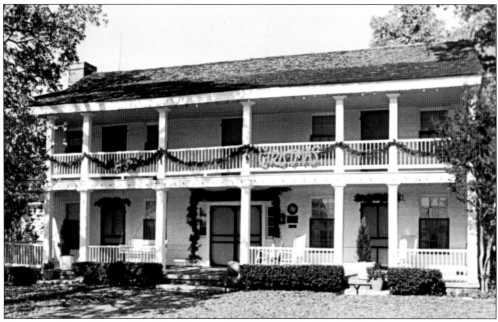

MEREDITH HART HOUSE. Built by slaves in 1856 for the Hart family, this home stands on the site of a former Comanche trail just east of Rio Vista. Nails were not used in the home's construction, and oxen from Louisiana carted finished lumber. Hart was a Texas Ranger, a cattleman, and a patriot. Dr. R.W. Kimbro and his wife, Tommie, completed the home's restoration and built additional rooms in 1968. (Courtesy of Layland Museum.)

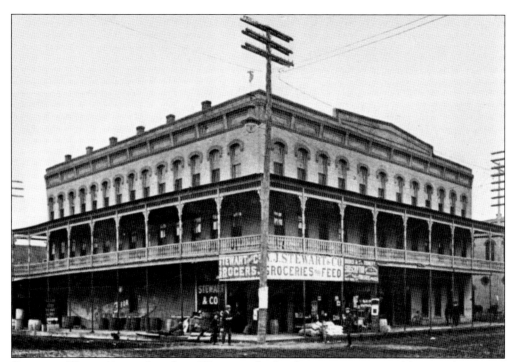

CLEBURNE HOUSE OPENS. Josephine Wren was the first businesswoman in Cleburne. She erected a frame building on the northwest corner of the square in 1867, the year Cleburne was organized. Other owners built a three-story hotel with a large balcony (shown here) at that location. Besides being a fine hotel, the establishment hosted dinners, formal balls, dancing, and church bazaars. Fire destroyed the third floor in the late 1920s. (Courtesy of Layland Museum.)

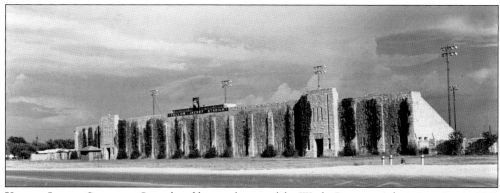

YELLOW JACKET STADIUM. Completed by employees of the Works Progress Administration in 1941 on pastureland where Emmett Brown grazed Holstein dairy cows, this stadium continues to serve as Cleburne's football home. At the time of its opening, "The Rock," as the stadium was dubbed by former football coach Chuck Curtis, could seat 3,800 fans. The press box was rebuilt in 2008, and a Texas Historical Marker was placed there in 2011. (Courtesy of Layland Museum.)

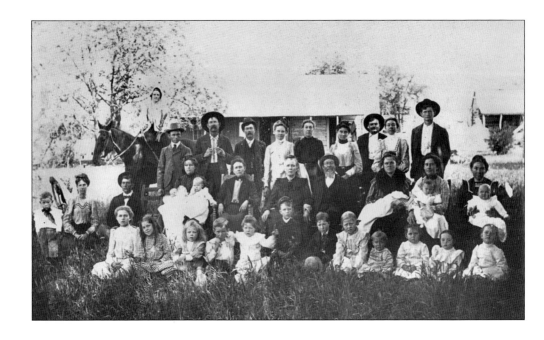

MENEFEE FAMILY REUNIONS. Brothers Rev. W.O. Menefee and Henry Franklin Menefee were early settlers in Johnson County. Both were member of the 30th Texas Cavalry and settled on land near Rio Vista. Henry was a farmer, and he and his wife, Amanda, built a log cabin where Rio Vista State Bank would be built decades later. W.O. Menefee signed the petition for the creation of Johnson County. Annual gatherings of the Menefee family began in 1890 and usually met in the Rio Vista area. Lowell Smith, a grandson of Henry Menefee and John Wesley Smith, lives with his wife, Shirley, in the restored home place of his paternal grandfather. The reunion photograph above was taken about 1900. Family members still meet each year (below) and continue adding to the scrapbooks filled with images and histories of past generations. (Both, courtesy of Lowell "Stretch" Smith.)

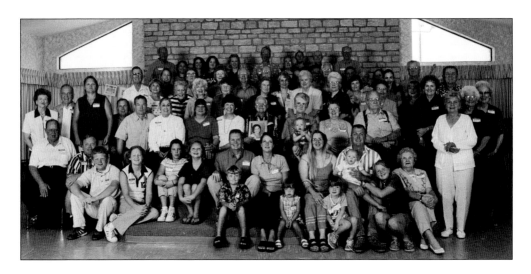

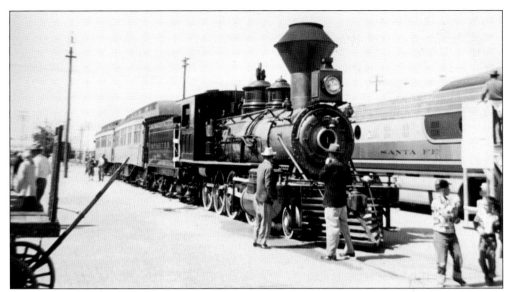

1954 County Centennial. Over 600 people preformed in the musical *Johnson County Recall*, including Miss Johnson County and the Princess of the Jersey Isle. The performance was part of the mammoth celebration of the county's centennial. Sisters of the Swish pins and shave permit pins were worn by citizens, many of whom dressed as pioneers. Parades, parties, and a train robbery reenactment led by members of the Johnson County Sheriff's Posse were part of the activities. The Cyrus K. Holiday 1880 steam engine (above) puffed its way on the Santa Fe Railroad tracks through the county at speeds of up to 20 miles per hour. T.L. Cowan shoveled the coal, and W.L. Robertson was the acting engineer. The two passenger coaches were lit with kerosene lamps and heated with potbellied stoves. The county's population in 1950 was 31,390; by 2010, it was 150,934. (Both, courtesy of Layland Museum.)

MCPHERSON HOUSE. Home to the Joshua Area Chamber of Commerce since 2012, the residence shown here was built in 1898. The McPherson family deeded the house, at 402 South Main Street, to the Joshua School District. For a time, it had been used as the senior center. The home had its formal dedication in 1985. The Lions Club restored the carriage house, and the grounds were opened as a park. (Courtesy of Joshua Area Chamber of Commerce.)

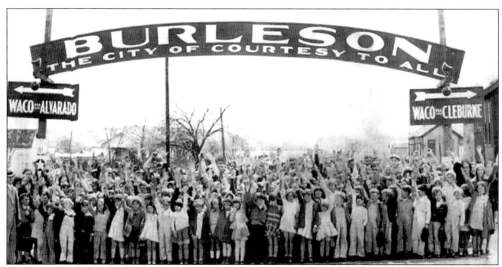

WELCOME TO BURLESON. Residents gathered for this photograph in 1932 to celebrate the new sign advertising their town. In 1940, the population was 573, but it grew rapidly during the 1950s, reaching 2,345. The city celebrated 100 years in 2012. (Courtesy of Burleson Heritage Foundation.)

Seven

LEARNING OPPORTUNITIES

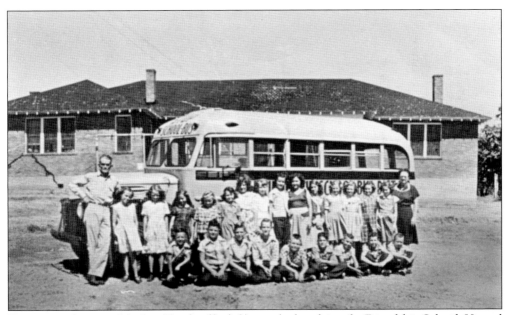

FRIENDSHIP SCHOOL. Mr. Lois Tarpley (far left) was the bus driver for Friendship School. He and his wife also cooked for the school. The school's teacher, A.N. Rudolph (far right), poses with the fifth- and sixth-graders in 1965. The community of Friendship had a school until 1965, when it consolidated with Cleburne schools. (Courtesy of A.D. and Lucille Jackson.)

PIONEER EDUCATOR AND MINISTER. As the first appointed county superintendent of public schools in 1897, J.R. Clarke oversaw 88 community schools and two school districts. In 1868, he became the first called minister of First Baptist Church and also served as principal of the Cleburne Institute, which met in the same building. (Courtesy of Martha Forrest.)

BARNESVILLE SCHOOL. Barnesville was on the stagecoach road between Waxahachie and Cleburne. Nearby parents paid subscriptions to fund the first school, built in 1879. Before this, the children attended school at a local farm. The school (shown here) had four classrooms and an auditorium. It was torn down in the 1940s. (Courtesy of Mollie Mims.)

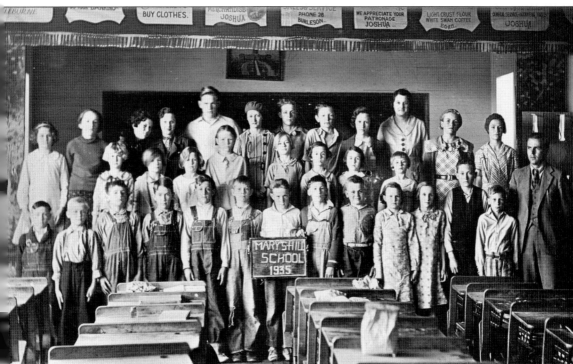

MARY'S HILL SCHOOL. Marystown, named by merchant Thomas Hollingsworth for his wife, Mary, went by that name until a post office was opened in 1869 and the name was changed to Mary's Hill. In 1916, the Union Hill and Marystown Schools consolidated to form a new school. There was no set number of weeks in the school year. When the money to pay the teachers was exhausted, the school year ended. Mary's Hill, east of Joshua, was part of a busy community with a cotton gin, gristmill, stores, churches, and a blacksmith shop. Shown in this 1935 photograph of a Mary's Hill School classroom are, from left to right, (first row) unidentified, Charley Owens, Hubert Bandy, Jack Carlock, unidentified, Don Shumeck, Clinton Collins, Junior Brawner, "Runfast" Tarver, ? Tarver, Mary Charles, Winston Eaken, Wesley Brawner, and teacher Robert Chapman; (second row) Melba Webb, Imogene Ownes, unidentified, Ruthie Buck, Francis Owens, Billie Davidson, Lucille Briley, and Jane Littlefoot; (third row) Marian Eaken, Thelma Bandy, two unidentified, Dick Carlock, Iris Durham, J.T. Collins, James Buck, Drennon Charles, teacher Mrs. Dryer, ? Tarver, and Eula Owens. The school closed in 1945. (Courtesy of A.D. and Lucille Jackson.)

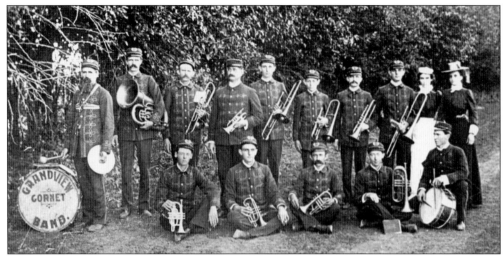

GRANDVIEW MAKES MUSIC. The Grandview Cornet Band played for many community events, including a picnic at Island Grove. Seen in the 1895 photograph above are, from left to right, (first row) Chet Odom, Otis E. Hale (band director), Billy Wagner, Peck Elliott, and Elbert English; (second row) Bill Web, two unidentified, Mr. McMasters, Matt Hale, Ernest Hale, Dr. Edmunson, and Will Hale, with visitors Florence Riley and Mabel Hale. Below, the Grandview Collegiate Institute Band poses for an informal photograph in 1900. Shown are, from left to right, (first row) unidentified, Billie Malone, Dr. Edmunson, Billy Wagner, Ernest Hale, and Elbert English; (second row) Peck Elliott, Elmer Young, Billy Claunch, Matt Hale, Will Harrell, Otis Odom, Lawrence McCowan, Mac English, Hamp Savage, N. Matt Hale, and a customer, Otis Hale; (third row) Chet Odom and Will Hale. The fire of 1920 claimed the band hall, but the instruments were saved, and the band continued to play until about 1922. (Both, courtesy of Rudolph and Jessie McDuff.)

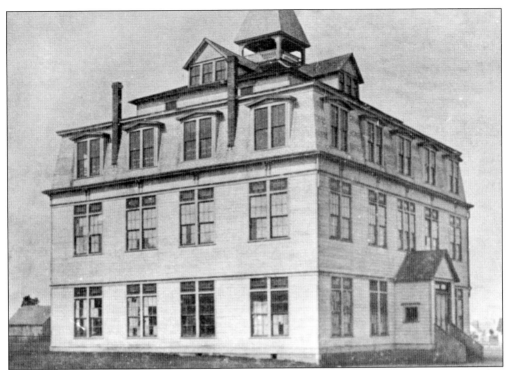

BURNETTA COLLEGE. The four-story, frame building housing Burnetta College in Venus opened in 1896 with 35 rooms to accommodate 250 students. The college was sponsored by the Disciples of Christ. A.D. Leach was the school's first president. There was also a large dormitory for boarders. Before closing in 1906 to become a public school, the peak attendance was over 350 students, with as many as 10 teachers. (Courtesy of Layland Museum.)

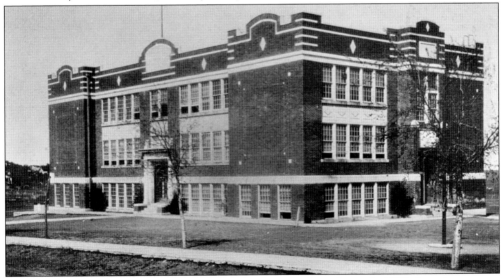

GRANDVIEW HIGH SCHOOL. The first high school was built in the early 1850s from logs cut on Chambers Creek. Mr. Quillin, the teacher, lived in a nearby tent. The brick school pictured here was used until 1985. The Zebras got their name from early striped jerseys worn by the football players. (Courtesy of Rudolph and Jessie McDuff.)

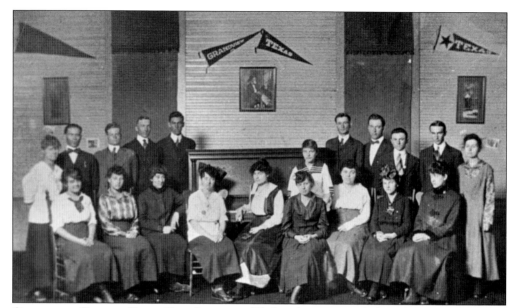

GRANDVIEW CHORAL CLUB. Grandview was filled with music, including the Choral Club. In 1907, the Grandview Collegiate Institute's elocution class boarded the train in town for a trip to Galveston. The following year, the school was re-chartered as a public school. The school building, erected in 1899, was the largest frame structure in the state. (Courtesy of Rudolph and Jessie McDuff.)

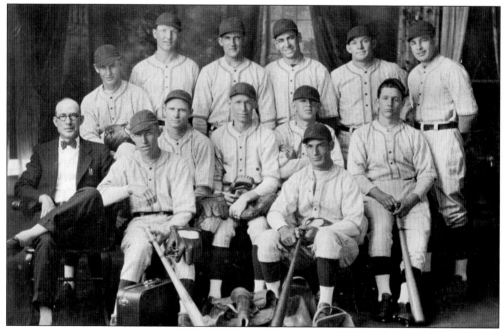

BASEBALL LEAGUE. The Cleburne Amateur Baseball League, sponsored by Schepps Bakery, is seen here in 1930. Shown here are, from left to right, (first row) Jack Brown (manager), R.D. Patton, Tuffy Layland, Lowell L. "Red" Harris, Jack Bowers Jr., Johnny Caldwell, and Mr. Jones; (second row) Lewis Stevens, J.B. Mckemie, Lawrence Crutcher, Clayton "Tut" Harris, Harold Watson, and Horace King. (Courtesy of Sandra Harris Neeley.)

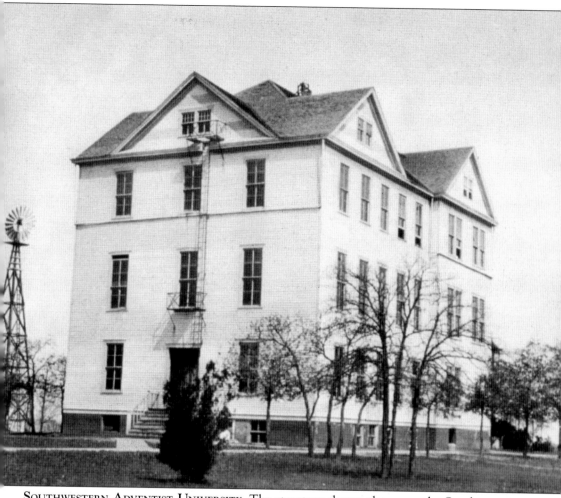

SOUTHWESTERN ADVENTIST UNIVERSITY. The structure shown above, on the Southwestern Adventist campus in Keene, was initially known as the Academy Building. Later called the College Building, it housed classrooms and administration offices. Built in 1895, it burned down in 1921. Other campus buildings included West Hall, built in 1919; Penuel Hall, which replaced the College Building in 1921; North Hall, built in 1894 and first known as "the home;" and the Normal Building, erected in 1912. Opened in 1994, the Chun Shun Centennial Library is a four-story building crowned with a clock tower and observation room. Over 100,000 volumes of books are housed there. Outside the main entrance is a bronze statue given by leaders from across Johnson County in recognition of Southwestern's contributions to the area. (Courtesy of Southwestern Adventist University.)

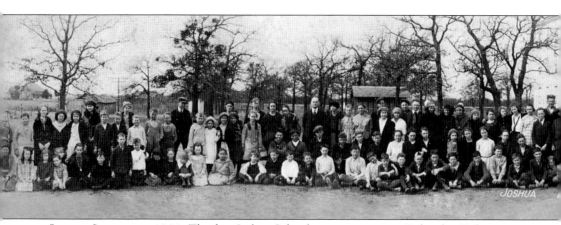

JOSHUA SCHOOLS C. 1900. The first Joshua School was a one-room, 40-foot-by-60-foot structure located west of the railroad tracks and built in 1890. This was succeeded by the three-story Willie Denton College with an almost 800-seat auditorium (shown as the largest building in the image). Land for the campus was given by Dr. John Ball, and building materials were donated by Theo Denton and other Joshua citizens. It opened in 1899 with 260 pupils and was turned over to the

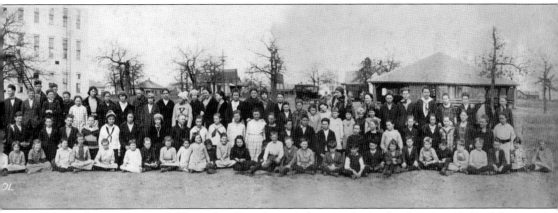

Joshua School District in 1909. Classes for all grades including post-high school were math, English, Latin, history, physics, chemistry and agriculture. Private paying students attended part of the year, while the rest of the year was made public. The name was changed to Joshua High School in 1917. A brick school that included 12 classrooms, office, and bookroom replaced the college in 1924. In 1936, a gymnasium was added. (Courtesy of Joshua Area Chamber of Commerce.)

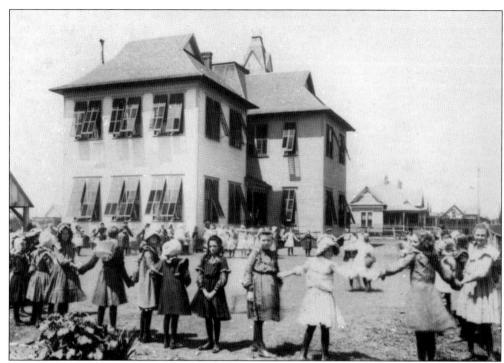

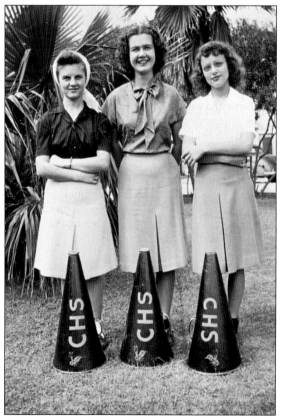

SCHOOL FOR GIRLS. Prof. Peyton Irving opened Irving Select School for Girls in 1878 with a curriculum of astronomy, English, chemistry, government, music, bookkeeping, and other subjects. Pictured here is the third location, on North Anglin Street in Cleburne. In this building, students could live upstairs. This school closed in 1898, and Irving Public School was constructed on the site in 1915. Peyton Irving was the first county school superintendent. (Courtesy of Layland Museum.)

CLASS OF 1947. From left to right, Jean Stewart (Addams House), Patsy Friou (Willard House), and Mary Jean Jackson (Barton House) were cheerleaders and classmates at Cleburne High School. The house system provided three large homerooms for girls and three for boys, allowing all four grades to be a part of each house. House members sat together in the auditorium during pep rallies and assemblies. The boys' houses were Riley, Wilson, and Edison. (Courtesy of Martha Mahanay Twaddell.)

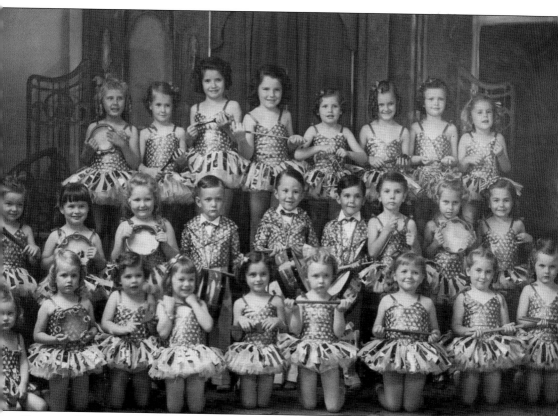

READY TO PERFORM. In her Cleburne home on McAnear Street, Adriel Lee Hamilton operated a grand private school in the 1940s, complete with lessons in dance, music, and theater. Performances were held at the Yale Theatre and involved elaborate costumes and stage sets. Hollywood musical choreographer Busby Berkeley, Hamilton's friend, assisted with set designs. School snacks, Snow Flake milk, and vanilla wafers were served by a gentleman wearing a white dinner jacket. The backyard playground included a merry-go-round and a bridge over a pond. Pictured prior to a kindergarten rhythm band recital on June 12, 1941, are, from left to right, (first row) Carolyn King, Marianne Rawland, Mary Aline Preston, Lynda Jones, Phala Joyce Gober, Darla Gene Meachaw, Nina Gean Wiseman, Nancy Rucker, and Beverly Hollingsworth; (second row) Dianne Boulware, Patsy Kanewski, Edwina Reynolds, Butch Gorski, Freddie Max Talkington, Bobby May, Glenda Grammar, Andra Austin, and Gene Ann Lankford; (third row) Carolyn Heath, Barbara Layland, Patsy Doty, Sandra Cumbie, Margaret Lee Preston, Jane Ballew, Cynthia Lee Lankford, and Martha Dickerson. (Courtesy of Margaret Lee Preston Frasier.)

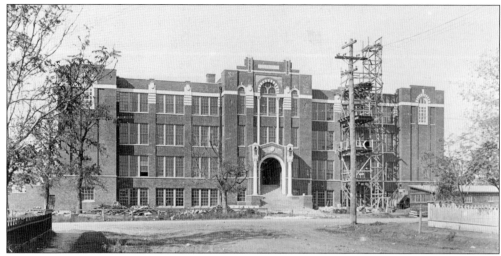

CLEBURNE HIGH SCHOOL UNDER CONSTRUCTION. Cleburne High School, completed in 1919 with three stories and a basement, became the junior high school and, later, part of Hill College before being purchased by the county. The Johnson County Guinn Justice Center was dedicated in 2004 after a complete renovation of the building's interior. A museum showcasing school memorabilia is in the basement. (Courtesy of Eddie and Betty Sewell.)

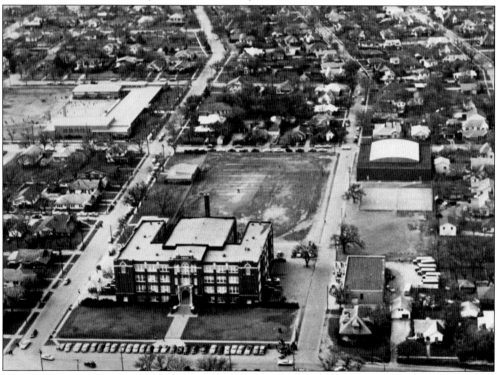

RHOME FIELD AND SCHOOL. Named for Joe Rhome, a student and captain of the 1920 football team, Rhome Field was located behind the high school. Yellow Jacket Stadium was completed in 1941. Coach Chuck Curtis called the stadium "the Rock" during his tenure in the early 1980s, and the name stuck. Cleburne Junior High School can be seen in the upper left. (Courtesy of the L.R. Coleman Estate.)

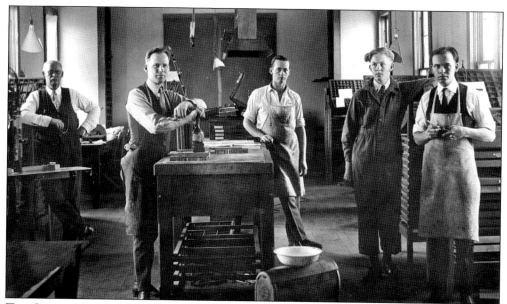

THE COLLEGE PRESS. Known later as Southwestern Colorgraphics, this printing company was among the businesses owned and operated by Southwestern Adventist University. Each year, hundreds of students learned the value of work in addition to their academic studies in Keene. Pictured in the type room of the College Press in 1924 are, from left to right, C.N. Woodward (manager), Hubbard Schulenberger, Frank Ables, Glenmore Carter, and Bill Sanders. (Courtesy of Southwestern Adventist University.)

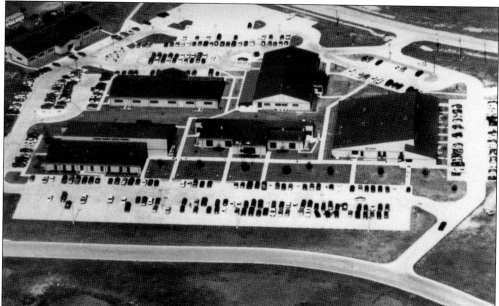

HILL COLLEGE. Since 1974, Hill College has had a presence in Cleburne. The campus, overlooking Lake Pat Cleburne, opened in 2000 and consists of 32 acres of land, plus an additional 15 acres leased from the city. Facilities include classrooms, a library, a student center, the Margie Faye Wheat Kennon Health Science Center, and the Tolbert F. Mayfield Administration Building. The Mayfields donated land for the campus. (Courtesy of Sheryl Kappus, PhD.)

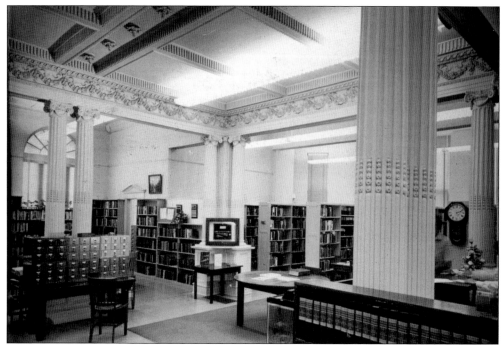

CENTER OF LEARNING AND PRESERVING. The Layland Museum is housed in the original Cleburne Carnegie Library (interior shown above), which is listed in the National Register of Historic Places. The Women's Club of Cleburne met with New York industrialist Andrew Carnegie to secure a $20,000 grant to fund a library. The building was opened in 1905 and remained a city library until 1978, when it expanded at a new location on West Henderson Street. The museum came into existence through a gift in 1963 from the family of William J. Layland, a local businessman. The Cleburne museum, shown below from the open clock of the Johnson County Courthouse, now displays a broad selection of North Central Texas domestic objects. The permanent collection numbers over 10,000 items and 75,000 photographic images. Collections not on exhibit are housed in the Lowell Smith Sr. History Center, home to the Gillespie Research Library and a classroom/teaching kitchen. There were 32 Carnegie libraries built in Texas, many of which have been demolished. (Above, courtesy of Layland Museum; below, courtesy of the *Cleburne Times-Review.*)

BOY SCOUTS AND CAMP FIRE. Posing in front of Roberts Manufacturing in 1962, Boy Scout Troop 678 (above) of Cleburne met next door in a two-story house provided by Gene Roberts. Shown here are, from left to right, the following: (first row) Ronnie Dobbins, Jackie Sewell, Carl Hinkle, Eddie Sewell, Marvin (Joe) Reeves, Larry Grigsby, and Robert Basin; (second row) David Parrish, Charlie (Mike) Hamilton, Greg Richter, Carter Bradley, Richard White, two unidentified, and Mickey Boyd; (third row) James Corbin, Charles Tuggle, Greg Elliott, Lee J. Hinkle (assistant Scoutmaster), Paul Corbin (Scoutmaster), Kenny Ard, Ronald Porch, and Michael Holmes. Pictured below in 1971 at the courthouse wearing their white Horizon Club jackets are, from left to right, Becky Brand, Linda Myers, Mollie Gallop, Jill Garrett, Gail Givens, Denora McClure, and Shirley Stinson. The Tesuya Council of Camp Fire began in the county in 1936. (Above, courtesy Layland Museum, below, courtesy of Mollie Mims.)

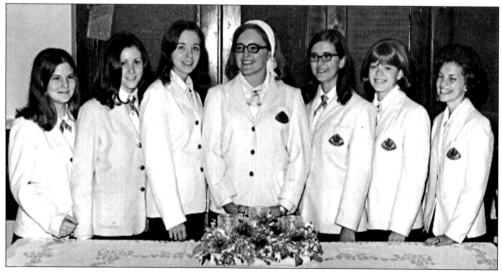

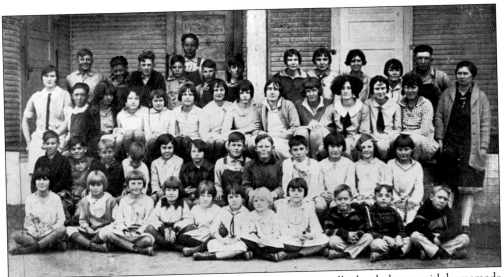

EDUCATION ACROSS THE COUNTY. Highland School, like many small schools, began with homemade desks, no books, and no maps or charts. In 1898, Highland's enrollment consisted of 16 boys and four girls. Other schools in the county were Greenfield, Rock Tank, Harmony, Lovejoy, Flat Prairie, Huff, In Loco, Greenfield, Concord, Price's Chapel, Chaney Springs, and dozens of others. (Courtesy of Layland Museum.)

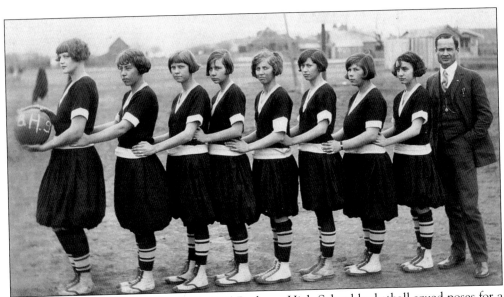

GIRLS' BASKETBALL TEAM. The 1924–1925 Burleson High School basketball squad poses for a team photograph. Shown here are, from left to right, Dorothy Sells, Daisy Rogers, Dot Carter, Marguerite Hurst, Imogene Price, Nell Stone, Willie May Hague, Nina Booth, and the coach, J.W. Norwood. (Courtesy of Burleson Historical Foundation.)

Eight

SEEDS AND SOIL

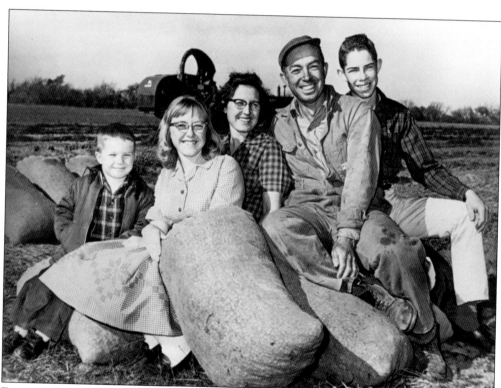

FAMILY OF FARMERS. Members of the Jackson family gather for a photograph in 1962. They are, from left to right, John, Darla, Lucille Carlock Jackson, A.D. "Don," and Jimmy. Their peanut farm was in Friendship, and they had been named farmers of the year by the *Fort Worth Star-Telegram*. Family members planted, hoed, sacked, and sold peanuts from their farm as well as from rented property. A.D. Jackson began driving a tractor at age 12. (Courtesy of the Layland Museum.)

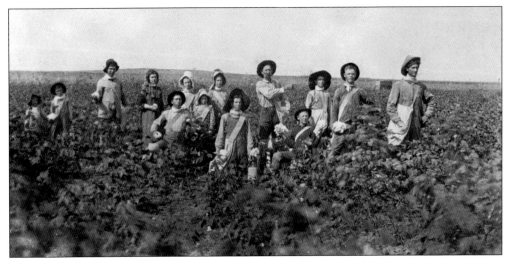

WHEN COTTON WAS KING. In 1896, John Ezell built a cotton gin on his land, located halfway between the communities of Alvarado and Cahill; it became a major business in rural Johnson County. Cotton production continued to expand in the area, and Ezell became a successful gin owner and farmer. J. Otto McLeroy Sr. took over operations in 1917, and it became known as McLeroy Gin. Cotton buyers were attracted to Alvarado by its two intersecting rail lines bound for major cotton markets in Dallas, Fort Worth, and Waco. Annually, the first bale of cotton in the county was a prizewinner over which much to-do was made. Below, the bale grown by Andy Thomas (left) on the Peacock farm in Sand Flat was presented on the courthouse square with much fanfare. (Above, courtesy of Michael Percifield; below, courtesy of Layland Museum.)

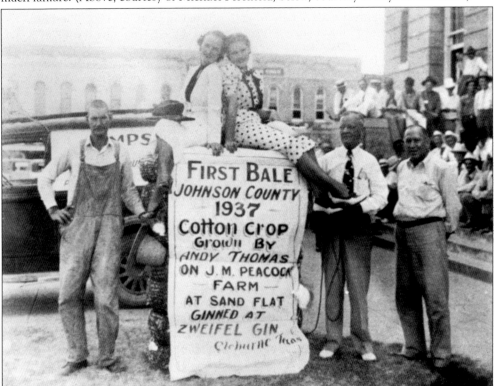

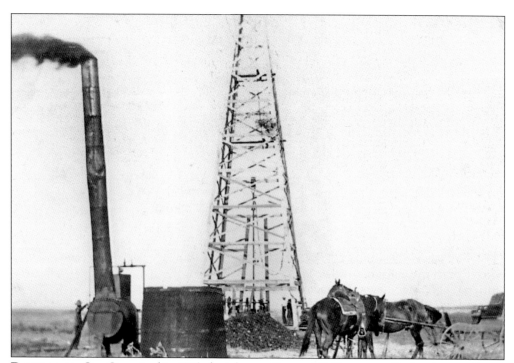

DRILLING FOR OIL. Organized in 1916, the Johnson County Oil Company of Joshua began offering stock at $25 per share. Its purpose was to purchase a drilling rig, tools, and casing for 2,000 feet and to drill in the county. The Anderson Well was the first. On July 4, 1932, a countywide basket dinner and barbecue was held at a well test site on the Giesen farm east of Joshua. The Bill Gregg Band began playing at 10:00 a.m., followed by speakers and the 144th Infantry Band. Boy Scouts provided traffic control. G.A. Featherston was in charge of drilling. Company officers were L.O. Bonham, L.H. Hunter, R.W. Plummer, and R.A. Barry. The company had over 10,500 acres leased in the county. No well provided a substantial amount of oil. (Both, courtesy of L.O. Bonham.)

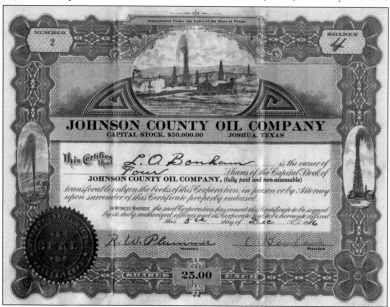

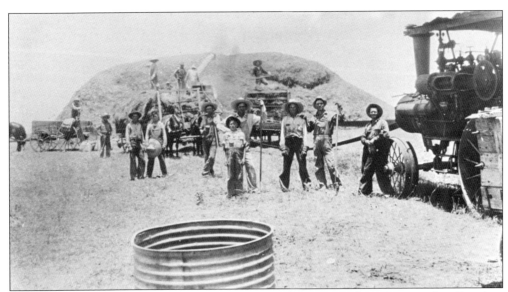

THRASHING CREW, 1927. Workers on the Doug Carrell farm pause for a photographer. Standing on the separator in the distance, with hands on hips, is Howard Carrell. Shown in the foreground are, from left to right, unidentified, Joel Thetford (holding straw hat), David Myers, L.C. Thetford (child), Wayne Myers, Leonard Owens and W.L. Carrell (next to the engine). Buck and Ball are hitched to the wagon. (Courtesy of Layland Museum.)

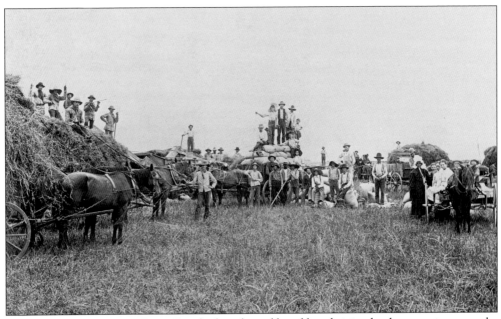

SHARING THE LAND AND WORK. Family, friends, and hired hands joined at harvest time to make sure the crops were done on time. By 1900, sharecroppers accounted for 48.8 percent of the farming. For over 20 years beginning in 1890, in addition to livestock production, wheat, grain, sorghum, and corn were major crops grown in the county. (Courtesy of Layland Museum.)

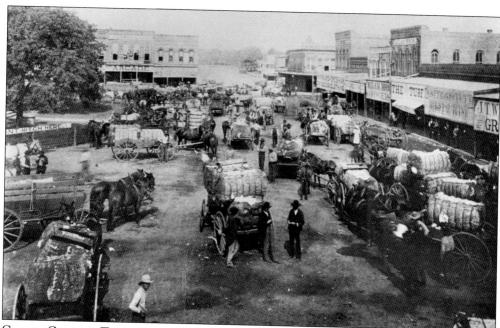

COTTON COMES TO TOWN. Wagons loaded with cotton filled the dirt streets around the courthouse in Cleburne's early years. By 1930, there were over 3,700 farms and about a dozen gins in the county, with three of the latter in Cleburne. Cotton was king for several decades, and by 1952, the average annual cotton production for Johnson County was 22,072 bales. (Courtesy of Layland Museum.)

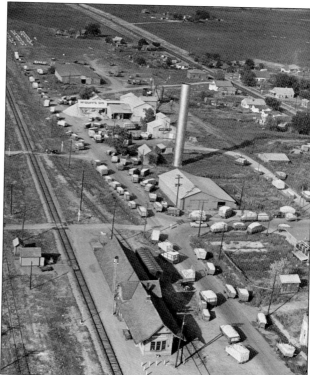

WAGONS FULL OF WHITE GOLD. S.E. McDuff owned the McDuff Gin (shown here) from 1938 until it burned down in 1953. At times, 1,000 bales of cotton sat waiting to be ginned on the three lots, and at its peak, about 15,000 bales were processed annually at the local gins. Other gins in town were the Coop and the Pinion Gin. (Courtesy of Rudolph and Jessie McDuff.)

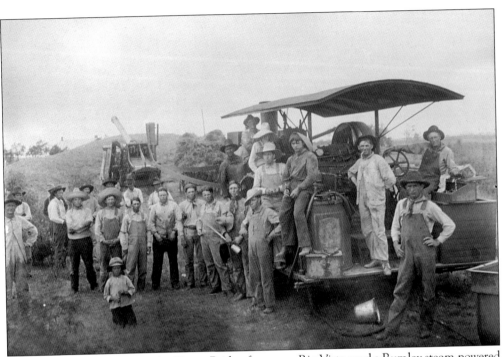

STEAM TRACTOR. Workers at the Henry Briden farm near Rio Vista used a Rumley steam-powered tractor to make harvesting easier. By 1910, the county population had grown to almost 35,000, and farming continued to be a major way of life. (Courtesy of Layland Museum.)

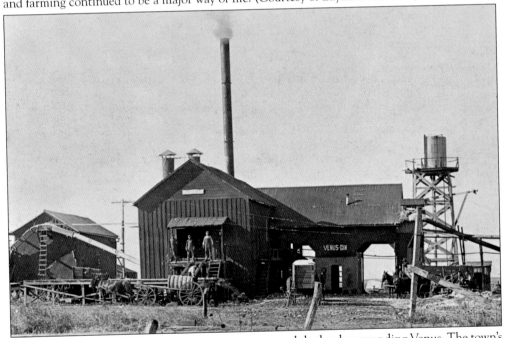

VENUS'S TOP CROP. For many years, cotton crops covered the land surrounding Venus. The town's four gins stayed busy separating cotton fibers from the seeds and, in the process, providing jobs. Ben Mahanay and Charles Giddings were grocery and cotton buyers, and Glenn Balch was one of the first ginners. There are no gins in Johnson County in 2013. (Courtesy of Layland Museum.)

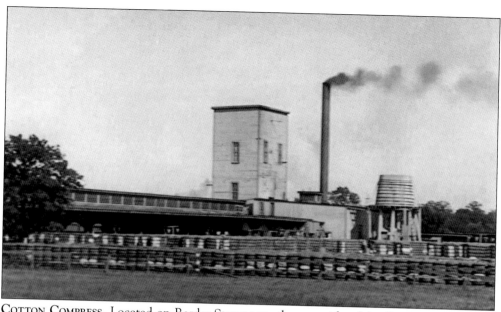

COTTON COMPRESS. Located on Border Street near the west side of the Santa Fe Railroad in Cleburne was the Texas Cotton Compress (shown here). At this facility, bales were put into a huge press, which extracted all the air from the cotton to reduce the size of the bale. The bales were then loaded onto boxcars and shipped to Galveston, where they were placed on ships and delivered worldwide. (Courtesy of Layland Museum.)

FOUR-ROW PLANTER. Dewey C. James Sr. began farming at the age of 14 with a team of mules and a plow. By the 1930s, he was one of the major farmers in the county, using equipment like the four-row planter (seen here with James). He also operated a dairy and raised chickens and sheep. James provided labor and equipment for other farmers' operations. (Courtesy of Dewey C. James.)

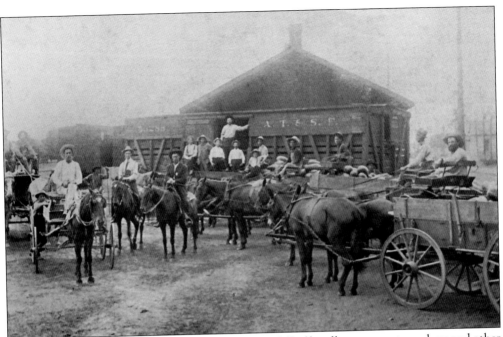

HAULING WATERMELONS. Farmers delivered wagons full of locally grown watermelons and other produce to the Atchison, Topeka & Santa Fe Railway in Cleburne. Produce was also sold at Market Square and to grocery wholesalers like Woolridge and Meals, located near the tracks on East Chambers Street. (Courtesy of Layland Museum.)

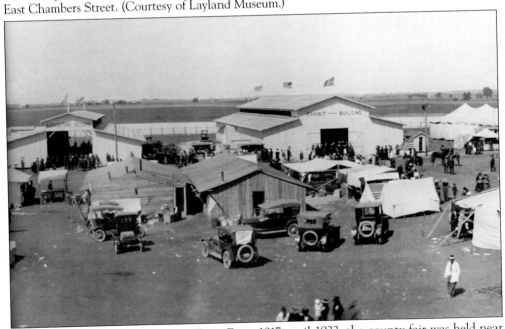

JOHNSON AGRICULTURAL COUNTY FAIR. From 1917 until 1922, the county fair was held near North Granbury and Kilpatrick Streets. Competitions included displays on canning, cattle, art, needlework, and baked goods. The grandstand and track was the sight of horse races and car races, farm animal shows, and football games. In 1917, during the inaugural fair, 15,000 people a day attended. (Courtesy of Layland Museum.)

JONES FARM NEAR BONO. Located on what was called the Glen Rose Star Route, the Ara and Gurvos Jones family farm operation consisted of raising grain, including oats and sudan, to feed the cattle. They also milked Holstein cows. This photograph was taken around 1950. (Courtesy of Sandra Davis Jones.)

FARM FRESH. Using only organic cultivation methods, from left to right, Jane and Bob Walker and Adam Walker planted five varieties of pecan trees on 15 acres south of Country Club Road in Cleburne, and they sell the annual crop. In 1876, thousands of acres in the county were dedicated to peaches, cantaloupes, and other fruits and vegetables. In 2013, more farms have begun raising crops organically, selling at farmers' markets and wholesale. (Courtesy of Mollie Mims.)

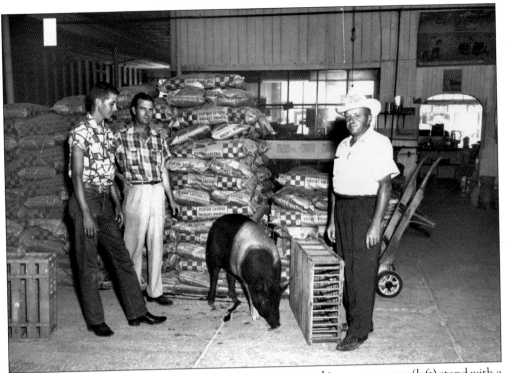

JOHNSON COUNTY FEEDER SUPPLY. This prize-winning pig and its young owner (left) stand with a Purina Chow representative at Johnson County Feeder Supply Company in Cleburne. The supply company's owner, E.M. Prather, is at right. Part of this building was the armory for Battery B, 132nd Field Artillery of the 36th Division of the Texas National Guard until it moved in 1951. (Courtesy of Layland Museum.)

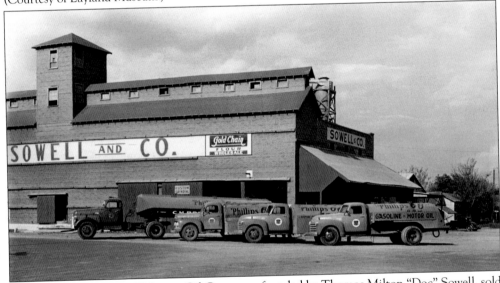

SOWELL AND COMPANY. Cleburne Oil Company, founded by Thomas Milton "Doc" Sowell, sold feed, grain, and wholesale groceries. Sowell purchased an interest in Gray's Feed Store from Sylvan Gray in 1946, and the business was renamed Sowell and Gray. Sylvan Gray later sold his interest to Dr. Tolbert Yater, and the firm became Sowell and Company. (Courtesy of Layland Museum.)

Nine

COMMUNITY CARETAKERS

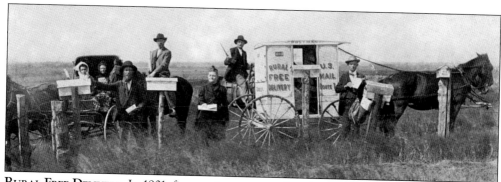

RURAL FREE DELIVERY. In 1901, five carriers were employed with Burleson's Rural Free Delivery and were paid $500 per year. The carriers were John Booth, William Self, Roger Alexander, James Hurst, and William Hurst. Carriers were permitted to take and sell postage, envelopes, postal cards, and money-order blanks. Iron collection boxes were placed in various locations. Automobiles were not used for delivery until 1917. (Courtesy of Burleson Heritage Foundation.)

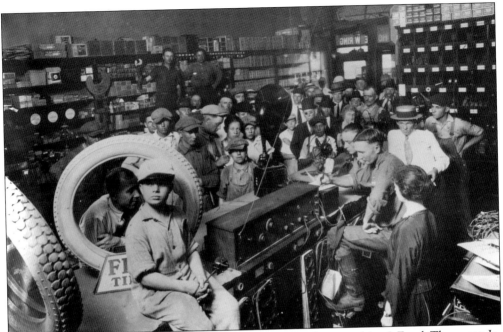

LIVE RADIO, 1922. Cash Zimmerman, framed by the tire, and, next to him, J. Frank Thompson Jr., listen to the crystal radio with the gathered crowd at Zimmerman's store. Thompson Sr. built this set and up to 20 a day, selling them as fast as they were made. He also helped lay the telephone line from Cleburne to Godley, and he built a police radio in 1934. (Courtesy of Layland Museum.)

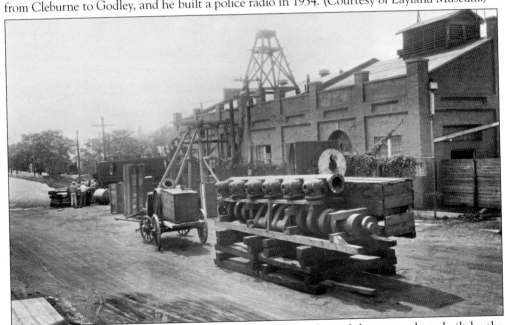

CLEBURNE WATER WORKS. George Grupe was superintendent of the water plant, built by the city in 1912 near Buffalo Creek off West Henderson Street. This location included two wells. Offices were added in 1932. By 1950, there were 4,200 water meters in Cleburne. In 2012, the city has 11,000 water meters, plus 1,300 fire hydrants and over 500 miles of water and sewer lines. (Courtesy of Layland Museum.)

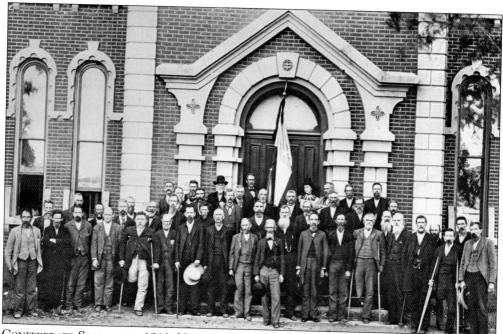

CONFEDERATE SOLDIERS C. 1910. Veterans of the Pat Cleburne Confederate Camp No. 88 held meetings in the Old Soldiers Room at the courthouse. In 1894, C.Y. and Ann Kouns donated land for the cemetery and to establish a Confederate Park for use by these soldiers and their descendants. In 1880, the cemetery association purchased an additional 20 acres from R.J. Chambers, increasing the cemetery to 36 acres. (Courtesy of Layland Museum.)

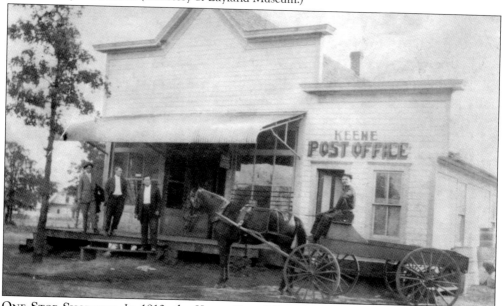

ONE-STOP SHOPPING. In 1910, the Keene Post Office, located south of the 10-acre Keene School campus, was also the local shopping center, including Grave's Store. Pictured here are, from left to right, Harry Reynolds, Claude Gage, E.S. Gage, and George Findley. North of the campus was the farm, barn, orchard, broom shop, and poultry yard. (Courtesy of Southwestern Adventist University.)

GRIGGS FAMILY HOMESTEAD. The Griggs family was similar to many pioneers who traveled far and endured hardships before building their new life in a new county. Families bonded and built communities. The Griggs family moved to the Alvarado area in 1860, the first year a census was taken in the county. Children attended school in the Union Church. Tuition was $1.50 per month. Shown here are, from left to right, Maggie Griggs, Kate Griggs, Annie Griggs, Ethel Griggs, Artelia Griggs, Howell Lewis Griggs, Nannie Griggs, Raymond Griggs, Jerry Griggs, Don Roger Griggs, and Ida Belle Griggs. The three at far right are unidentified. (Courtesy of Judy Nolen Slater.)

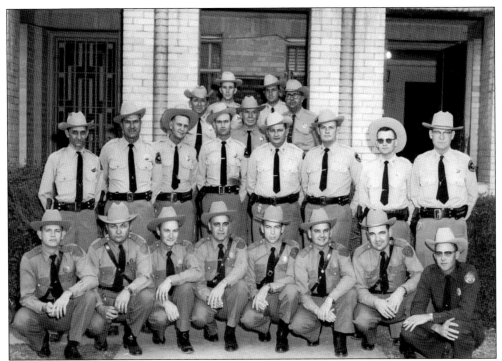

JOHNSON COUNTY SHERIFF DEPARTMENT. The Department of Public Safety and Game Wardens poses in 1959. Shown here are, from left to right, (first row) Jerry Gardner, Lewis Berneker, Doyle Spurlin, Robert Wight, Kenneth Bowling, Paul Busby, Billy Roe, and Bill Swope; (second row) all unidentified except for Sheriff Earl King at far right; (third row) Luke Johnson and four unidentified. (Courtesy of Sheriff Bob Alford.)

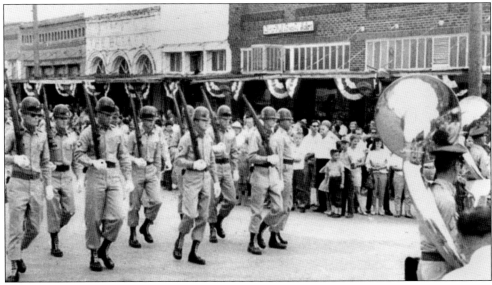

NIKE BASE SOLDIERS. Missiles were poised at the Nike base near Alvarado to protect citizens from enemy attacks. The base opened in 1959 with an underground launching area with elevators that brought up the guns. It closed 10 years later. Here, crowds watch the local soldiers during an Alvarado parade. Howard McCurdy was sergeant of the guard. (Courtesy of Michael Percifield.)

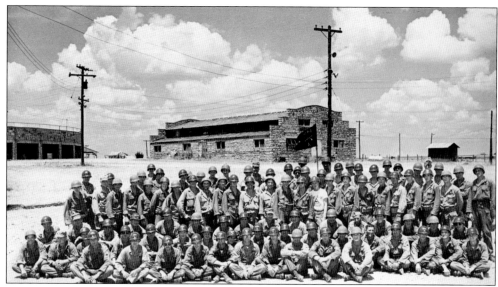

NATIONAL GUARD, 1953–1954. The 36th Infantry Division of the Texas National Guard, called to duty in 1917, initially used the location where the Johnson County Feeder Supply stands today. The Guard used this building, constructed in 1951, until the city purchased it in 1975. The first three commanders were Mayor James Degarmo, Judge John A. James, and Berry Taylor. (Courtesy of Melton and Bill Ann Billings.)

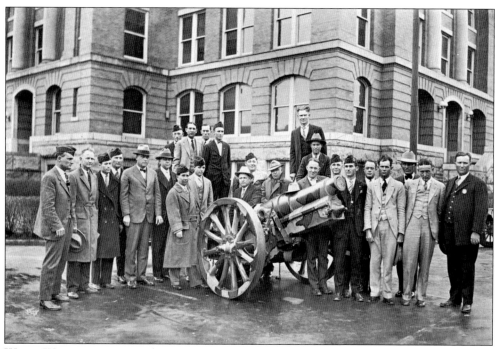

WORLD WAR I CANNON. Members of American Legion Post No. 50 donated its French 75-millimeter, rapid-fire, breech-loading cannon for a scrap-metal drive during World War II. The post later applied for a piece of artillery and received a 155-millimeter Japanese cannon from the US Army that is still displayed outside the post in Cleburne. (Courtesy of the Jack Burton family.)

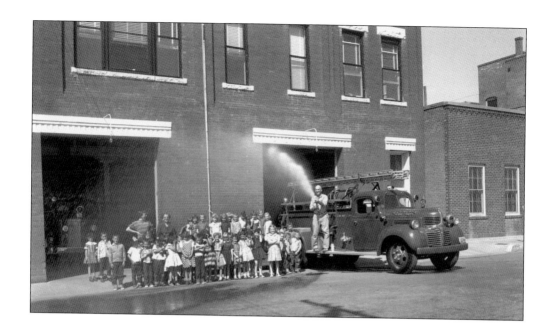

CLEBURNE FIRE DEPARTMENT. In 1891, the Cleburne Fire Department was established as a volunteer organization, with J.A. Lindgren as chief. There were three teams of horses, three trucks, 24 volunteers, and three paid drivers. In 1905, a new building was constructed for use as a fire hall and city hall. The first motorized equipment was purchased in 1913; by 1919, Old Tom and the other horses were retired. In 1950, there were eight employees. By 2013, the department had evolved into a 55-person, fully paid department operating three stations and a fire administration office. It responds to more than 4,400 calls annually. Children still enjoy tours of the facilities. A monument honoring firefighters, law enforcement officials, and members of the military of Johnson County is planned for placement at Winston McGregor Park in Cleburne. (Both, courtesy of Layland Museum.)

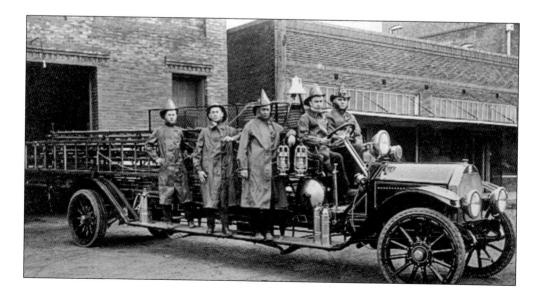

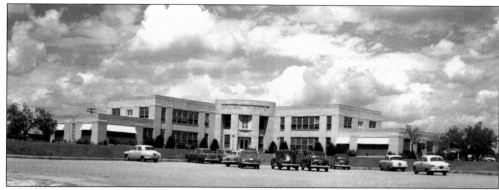

JOHNSON COUNTY MEMORIAL HOSPITAL. Cleburne Business and Professional Women raised $10,000 during its campaign to assist with the new hospital, which was built in 1948. In 1975, the hospital accommodated 224 beds. The facility also housed a seven-bed coronary care unit, eight beds in surgical recovery, and a surgery department on the top floor. The hospital was purchased in 1983 by Harris Methodist Affiliated Hospitals, which opened a new facility in 1986. (Courtesy of Layland Museum.)

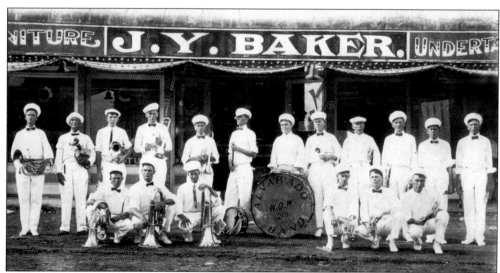

WOODMEN OF THE WORLD. The Alvarado Post 215 and its band (shown here) were active for years prior to merging with another post. The only unit remaining in the county is WOW Cleburne No. 4, which was formed in 1891. It provides flags or flagpoles to Layland Museum and schools and assists with other community needs. (Courtesy of Judy Nolen Slater.)

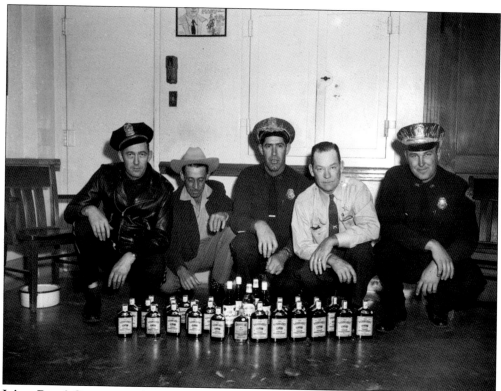

IT's A RAID! Cooperation between city and county law enforcement officers resulted in many liquor raids when the area was dry. Displaying confiscated items are, from left to right, Cleburne police chief Tom Kirkpatrick, Constable Robert Moore, Officer Herman Derden, Johnson County sheriff Earl King, and Officer Clay Dale Ferguson. In 1991, Rio Vista voted to sell some alcoholic products, and other towns have since voted for package stores or restaurant service. (Courtesy of Layland Museum.)

JOHNSON COUNTY JAIL. Completed in 1937, the Johnson County Jail (shown here), at 116 South Mill Street, served the county until the Johnson County Law Enforcement Center was constructed. It replaced an 1884 redbrick structure and was enlarged in 1972, and an annex was added in 1984. It had a capacity of 48 beds and private quarters for the sheriff's family. (Courtesy of Layland Museum.)

HANDS-ON LEARNING. In the above photograph, Jimmy Flynt proudly shows off his 4-H project, a Jersey cow. His family farm was located west of Cleburne, off Highway 67. In 1948, Cleburne School superintendent Emmett Brown, backed by businessmen and the Cleburne Rotary Club, helped organize a Jersey heifer giveaway for Johnson County 4-H and Future Farmers of America youth. They gave away 550 of them. Each student agreed to give back the first-born Jersey heifer to keep the program going. Sisters and 4-H members Linda (left) and Marsha Voss (right) lived west of the airport, near Cleburne. Below, they show the State Fair of Texas ribbons won for their Guernsey cows, Rose and Melba, in 1957. County 4-H clubs met in the basement of the courthouse. They learned how to care for animals and help provide food for their families. (Both, courtesy of Layland Museum.)

COUNTY COMMISSIONER, 1920. Commissioner E.M. Wilson was known for caring about the roads, especially those linking Burleson to Fort Worth and Cleburne. In 1916, he organized the Good Roads Club and collected funds for constructing graveled roads. Wilson also began the *Burleson News* in 1900 and partnered with his brother to erect a brick building, which in 2013 was home to Babe's Fried Chicken. (Courtesy of Burleson Historical Foundation.)

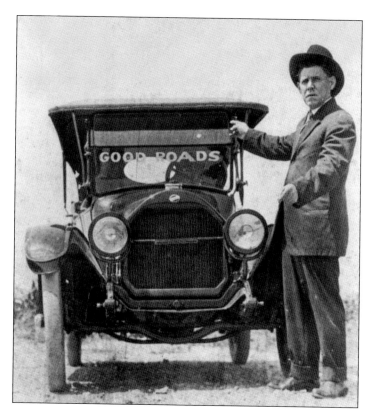

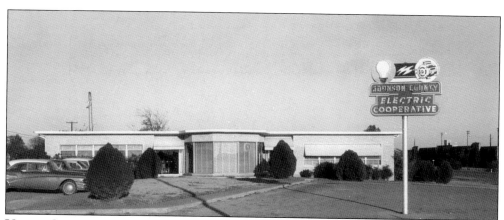

UNITED COOPERATIVE SERVICES. The Johnson County Electric Cooperative has been providing power to rural homes and businesses in North Texas since 1938. Headquartered in Cleburne, United Cooperative Services was formed in 2000 through the consolidation of Johnson County and Erath County Electric Cooperatives. Today, the co-op serves more than 76,000 meters and approximately 54,000 members across a 14-county service territory. (Courtesy of Layland Museum.)

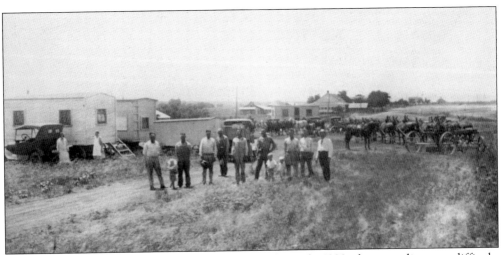

GODLEY ROAD-BUILDING. Godley was growing in the early 1920s, but traveling was difficult. Residents gathered to build roads, paving the way for more businesses and growth. The population at the time was 613, and the town had businesses on three sides. In 2000, the population was about 1,350. (Courtesy of Layland Museum.)

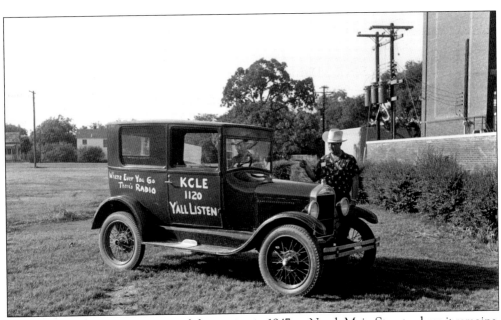

KCLE RADIO. George Marti opened this station in 1947 on North Main Street, where it remains. He was mayor of Cleburne for a dozen years, named to the Texas Association of Broadcasters Hall of Fame in 2002, and provides scholarships to about 200 students annually. Marti Elementary School was named in honor of him and his wife, Jo Marti. Pictured here is radio announcer J.B. Bryson. (Courtesy of Layland Museum.)

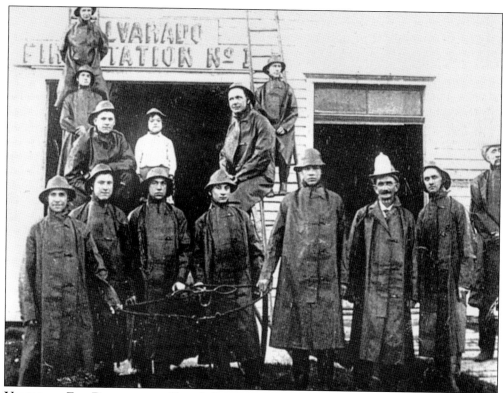

VOLUNTEER FIRE DEPARTMENTS. Founded in 1903 as a volunteer organization, the Alvarado group shown above evolved into a paid staff that covers almost 48 square miles of service. Volunteer fire departments in the county in 2013 were Alvarado, Blue Water, Bono, Briaroaks, Cresson, Godley, Grandview, Joshua, Keene, Liberty Chapel, Rendon, Rio Vista, and Venus. There is also a county Emergency Services District No. 1, formed in the 1950s as a Rural Fire Prevention District. Many of the volunteers are also trained as first responders. Departments hold annual events to raise needed funds. The Joshua Fire Department, pictured below, opened a new central fire station in February 2013 on North Main Street, 60 years after the volunteer fire department was established. (Above, courtesy of Michael Percifield; below, courtesy of Joshua Area Chamber of Commerce.)

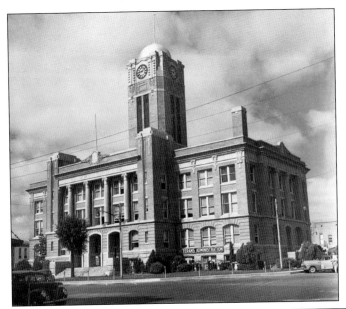

VETERANS ADMINISTRATION. There was a Veterans Administration office in the courthouse for decades, and several veterans groups held annual meetings there. In 2013, there were over 13,500 veterans living in Johnson County. They are served by a county Veterans Services office in the courthouse and one in Burleson. Annually, the two locations help about 3,600 veterans and their family members. (Courtesy of Layland Museum.)

SANTA FE SANTA. Engineer Joe Gerard (pictured as Santa) got to know the folks in the Indian Territory who lived along his train route between Cleburne and Purcell, Oklahoma, from 1901 until his retirement in 1943. During Christmas, wearing the suit his wife made, Gerard left newspapers, toys, and gifts to anyone who posted a white flag beside the tracks. Gerard Elementary School is named in his honor. (Courtesy of Nancy Foley.)

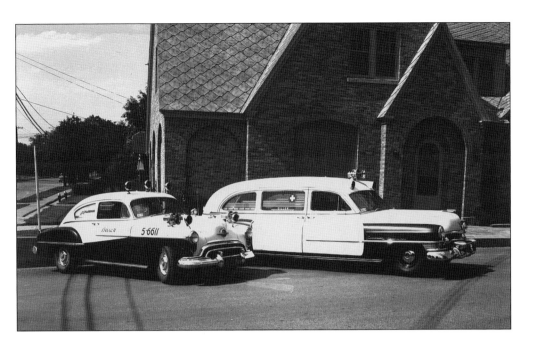

FIRST FUNERAL HOMES. P.C. "Pete" Dillon established the first exclusive funeral parlor in Johnson County in 1905. With his sons Verne and Boyd, he built a funeral home in Cleburne in 1930, shown above. In 1906, he received one of the first embalmer's licenses issued in Texas, No. 273. Dillon owned the first ambulance in Cleburne and the first factory-made hearse. The ambulance was horse-drawn. Dillon was born in 1873 in a log cabin located across from where the Cleburne police station now stands. The Dillons opened an Alvarado location, where they also sold furniture and appliances, shown below. (Both, courtesy of Layland Museum.)

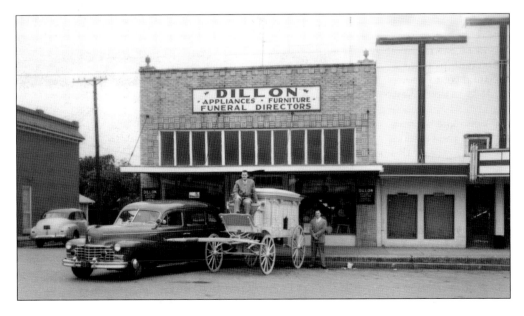

BURLESON FIRE DEPARTMENT. This department began in 1925. Its first piece of equipment was purchased from the War Assets Department. By 1998, the paid staff included a chief, an operations commander, and four firefighters. Today, there are 31 personnel who operate out of three stations and provide services to more than 38,000 people within the city of Burleson. (Courtesy of Layland Museum.)

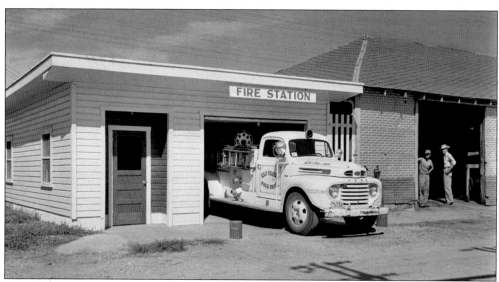

RIO VISTA FIRE DEPARTMENT. The volunteer fire department was formed in 1950 when the local Lions Club purchased a fire truck from the county for $1 and donated it to the city. The first chief was Marion "Tuffy" Gilbert. In 1979, the department purchased land on the south side of the square and constructed offices, complete with a kitchen and meeting rooms. (Courtesy of Layland Museum.)

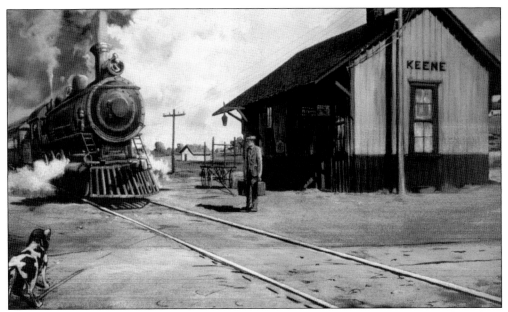

"OLD BETSY." In December 1902, the first train pulled into Keene. The new railroad ran from Cleburne to Egan and had one stop, in Keene. The train, operated by a steam engine called "Old Betsy," had a coal car, wooden baggage car, and passenger coach. It served as the primary means of transportation for 20 years. Old Betsy is now the name of Keene's main street. (Courtesy of Southwestern Adventist University.)

CHAMBER OF COMMERCE. Promoting the community and its businesses is the mission of the Cleburne Chamber of Commerce. In 1919, the Board of Trade and the Commercial Club joined forces to organize the chamber. Coleman Motor Company and the chamber joined forces to promote local shopping. (Courtesy of the L.R. Coleman Estate.)

PRESERVING OUR COUNTY HERITAGE. Since being founded in 1965 by Tommie Miles Kimbro, the Heritage Assembly has held an annual Heritage Ball. Funds raised are used for the restoration, appreciation, and marking of historical sites and events in Johnson County and for other ways that improve the community. Each year, the high school seniors among the members are presented at the event. The 1977 pages, shown here, are, from left to right, (first row) Lezlie Olson, Julie Auldridge, and Tammy Brown; (second row) Martha Mahanay, Becky Anderson, Lisa Hyde, Leigh Line, Luanna Ward, Elizabeth Hill, and Sue Ann Smith. By 2012, the organization has raised over $1 million in donations. Besides scholarships, the money has aided charities, including the Burleson Heritage Foundation, Camp Fire USA, the Brazos Chamber Orchestra, Layland Museum, CASA, the Buffalo Creek Association, Whistle Stop, Sons of Confederate Veterans, Community Partners of Johnson County, Christmas in Action, Cleburne Performing Arts Foundation, Goodfellows, Johnson County Heritage Foundation, the American Historical Rail Road Foundation, and the Carnegie Players. (Courtesy of Martha Mahanay Twaddell.)

BIBLIOGRAPHY

Abernathy, Frances Dickson. *The Building of Johnson County and the Settlement of the Communities of the Eastern Portion of the County.* MA thesis, University of Texas, 1936.

Block, Viola. *History of Johnson County and Surrounding Areas.* Waco, TX: Texian Press, 1970.

Byrd, J. *History and Description of Johnson County and Its Principal Towns.* Marshall, TX: Jennings, 1879.

Gordon, Dudley M. *The History of Cleburne.* MA thesis, University of Texas, 1929.

Guinn, Ernest E. *A History of Cleburne.* MA thesis, University of Texas, 1950.

Johnson County History Book Committee. *History of Johnson County, Texas.* Dallas: Curtis Media, 1985.

Joshua Historical Committee. *Joshua: As It Was and Is.* Cleburne, TX: Bennett Printing Company, 1977.

A Memorial and Biographical History of Johnson and Hill Counties. Chicago: Lewis, 1892.

Mims, Mollie Gallop Bradbury. *Cleburne.* Charleston, SC: Arcadia Publishing, 2009.

DISCOVER THOUSANDS OF LOCAL HISTORY BOOKS FEATURING MILLIONS OF VINTAGE IMAGES

Arcadia Publishing, the leading local history publisher in the United States, is committed to making history accessible and meaningful through publishing books that celebrate and preserve the heritage of America's people and places.

Find more books like this at
www.arcadiapublishing.com

Search for your hometown history, your old stomping grounds, and even your favorite sports team.

Consistent with our mission to preserve history on a local level, this book was printed in South Carolina on American-made paper and manufactured entirely in the United States. Products carrying the accredited Forest Stewardship Council (FSC) label are printed on 100 percent FSC-certified paper.

MADE IN THE
USA